LOUGHBOROUGH
THROUGH TIME

Stephen Butt

AMBERLEY PUBLISHING

First published 2013

Amberley Publishing
The Hill, Stroud, Gloucestershire, GL5 4EP
www.amberley-books.com

Copyright © Stephen Butt, 2013

The right of Stephen Butt to be identified as the
Author of this work has been asserted in accordance with
the Copyrights, Designs and Patents Act 1988.

ISBN 978 1 4456 1526 4 (print)
ISBN 978 1 4456 1549 3 (ebook)

British Library Cataloguing in Publication Data.
A catalogue record for this book is available from the
British Library.

Typesetting by Amberley Publishing.
Printed in Great Britain.

Contents

Introduction

The first chapter in the history of any English town, especially a settlement in the English East Midlands, is often devoted to speculation regarding its pre-Roman existence. Further chapters usually consider the Roman legacy, specifically the networks of roads which are still so apparent today, and continue with the effect on the landscape and the native culture of the waves of invading peoples, their culture and language, including the Saxons, the Vikings and the Normans.

This book focuses on the history of Loughborough that has been recorded by means of photography and, in a few instances, local topographical artists, and therefore charts the development of the town since the early decades of the nineteenth century. However, this more recent history must be placed in context. The development of any settlement is a gradual and usually haphazard process, and change is constant. A photograph or an artist's impression of a scene is of one moment in time.

Readers who were born or have lived for any time in Loughborough will know the town for its busy Market Place and the shopping streets that surround it. They will remember the names in the High Street, especially those they once patronised, now with their familiar twentieth-century frontages and occupying buildings which, in many cases, have survived for centuries and have seen shopping trends come and go.

In the Market Place, they will remember the half-timbered Lord Nelson public house, now Dorothy Perkins. They will also recall the many events that have taken place in that arena over the years, such as the meetings of the hunt, or the Golden and Diamond Jubilee celebrations for Queen Victoria, and the Coronation celebrations for Edward VII, who spent so much time in the nearby Leicestershire countryside.

If their families have lived in the town for several generations, they may remember the Sparrow Hill Theatre, later to become a free church,

then a lecture hall and music salon, a meeting place for the Manchester Unity of Oddfellows, and even later, Adkinson & Freckelton's Antiques Market, which, in the twentieth century, is occupied by a shop selling food for the many new communities in the town. It is difficult to imagine that where the refrigerated display units now stand, the 'Two Barbers of Physic, Fun and Figaro' once performed alongside 'Master B. Grossmith the celebrated juvenile actor' who was, when he stood in the limelight on the stage of the theatre in 1836, just seven years of age.

Reminiscences of a place and time are very personal. The author remembers the town hall for concerts by the William Davis Construction Group Brass Band, inspiring performances by the Leicestershire Federation of Youth Choirs, and for the one evening when the eminent composer Sir Michael Tippett conducted the Leicestershire Schools Symphony Orchestra.

The origins of Loughborough are lost in the proverbial mists of time. It is probable that the town was located close to an important Bronze Age trading route that crossed the country from east to west and was later used by the Romans. Possibly a settlement grew up around places where merchants and traders would meet.

However, its recorded and place name history confirms that Loughborough was a Saxon settlement, although street names such as Baxtergate, Churchgate, Woodgate and Pinfoldgate reveal also a Scandinavian influence. The first surviving document to give Loughborough a recognised name was the Domesday Book of 1086, in which the town is recorded as 'Lucteburne'.

From as early as the thirteenth century its weekly market attracted traders from the wider area and brought a busy prosperity to the town. Situated in the heart of the modern town, the market is still held on Thursdays and Saturdays with over 125 traders selling their goods. In 2013 plans were announced to invest more than £150,000 in refurbishing the historic Market Place.

Industry came to Loughborough in the late sixteenth century with the introduction of the stocking frame. William Lee, from nearby Nottinghamshire, invented the stocking frame in 1589, and the mechanisation of the textile industry continued with John Heathcote's lacemaking machines in the early eighteenth century. In his youth, Heathcote was apprenticed to a framesmith in Loughborough, where he later built a factory in partnership with Charles Lacy, a Nottingham manufacturer; but in June 1816 their factory in Mill Street, now Market Street, was attacked by former Luddites, thought to be in the pay of the lacemakers of Nottingham, and their fifty-five lace frames

were destroyed. Ten of the men were apprehended for the felony, and eight of them were executed.

A blue heritage plaque was erected in 2007 at No. 38 Leicester Road, Heathcote's former home, where a secret cellar had been discovered with a tunnel leading into the back garden through which it is believed he could have escaped if the Luddites had attacked.

As in nearby Leicester, which had endowments of the wealthy sixteenth-century wool merchant William Wyggeston, education in Loughborough still benefits today from the legacy of Thomas Burton who, in 1495, left money to pay for priests to pray for his soul. These priests founded the institution that became Loughborough Grammar School. Classes were held in Loughborough's parish church until 1852 when the Burton Walks campus was created. Today, the Grammar School forms part of the Loughborough Endowed Schools, which includes Loughborough High School and Fairfield Preparatory School.

Further education came to the town in 1909 when a small Technical Institute in the centre of Loughborough was established, providing local facilities for further education and offering courses in technical subjects, science and art. The successor to this institution was awarded its charter in 1966 as the Loughborough University of Technology, which became Loughborough University in 1996, and most recently it has been joined by the Loughborough College of Education and Loughborough College of Art and Design. The university now occupies the largest single-site campus in the country, covering 438 acres of land.

Close to the university is the Royal National Institute for the Blind College, which provides educational and vocational opportunities for people with a wide range of disabilities and from many social and ethnic backgrounds.

The heritage of the former Technical Institute, which itself drew upon mechanical developments in the local textile industry, is seen today in the number of engineering and technology-based businesses in Loughborough and the surrounding area. The origins of the Falcon Works of Brush Traction in Loughborough date to 1865 when a local timber merchant, Henry Hughes, began building horse-drawn vehicles. By around 1867, the company had expanded into the construction of steam engines, and it was purchased by the Brush Electrical Engineering Company in 1889. Throughout the twentieth century, Brush built not only steam engines but also aircraft for De Havilland, fuselages for Lancaster bombers, and engines and gearboxes for a wide range of transport, including tramcars and buses. The locomotive

works is still occupied by the Brush Traction Company today, and is in use for the building, overhaul and repair of locomotives, including the power units for the Eurotunnel electric locomotives.

Possibly the most charming and widely used products to have been created in Loughborough are the extensive range of Ladybird books. Henry Wills opened a bookshop in the town in 1867 and later expanded his business into printing and publishing guidebooks and street directories. He was joined by William Hepworth in 1867. Wills and Hepworth published their first children's books under the Ladybird imprint in around 1915 and reorganised their company to trade as Ladybird Books in 1971 because of the immense and enduring popularity of the books. In the 1960s they produced their Key Words Reading Scheme which has been used widely in British primary schools.

Ladybird Books became part of the Pearson Group in 1972 and in 1998 merged with Penguin Books, along with other well-known names in children's books including Puffin, Dorling Kindersley and Frederick Warne. Ladybird's printing facility in Loughborough closed at the same time.

The charming books produced by Messrs Wills and Hepworth are still treasured and widely read. Their size and the number of pages in each book were dictated by the fact that each complete book was produced from one large sheet of paper, which saved on printing costs. With their tough covers, they were long-lasting and resilient to rough use. They were certainly of their time in terms of cultural style and vocabulary, but nevertheless provided quality material for millions of young readers. The Ladybird brand also created work for a number of local artists, many of whom were students at local art colleges. Today, the heritage of Ladybird Books is celebrated with displays at the Loughborough Library in Granby Street and in the nearby Charnwood Museum.

Loughborough is in the heart of England. It has always been at the crossroads of thought and invention. Faced with the recession of the early twenty-first century it is facing up to the challenge of reinventing itself. It is something that it has done continually for more than a thousand years.

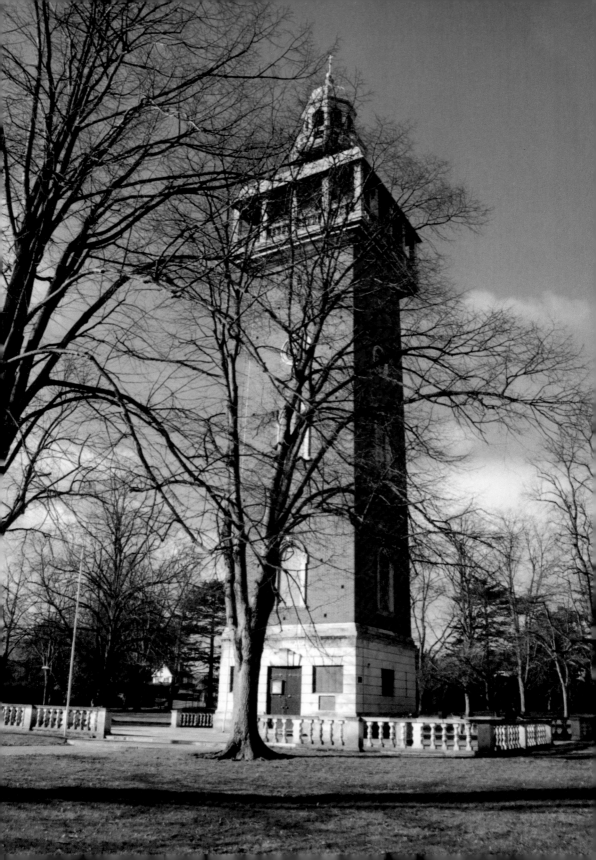

Acknowledgements

Many organisations and individuals have given willingly of their time and knowledge in assisting me in the creation of this book. I am most grateful to them for sharing their knowledge and their archive photographs. In particular I would like to thank the following individuals and organisations:

The Squire de Lisle for permission to reproduce photographs from his family's archives of the Garendon estate, Grace Dieu and Mount St Bernard's Abbey.

George Dawson, Honorary Curator of the John Taylor Bell Foundry (UK Bell Foundries Ltd).

Jennifer Clark, University Archivist, University of Loughborough.

Max Hunt for permission to use photographs from the collection and work of the late Walter Leeson.

Sue Blaxland and Steve Horsfield of the Leicestershire & Rutland Gardens Trust.

Tylers Department Store, Loughborough.

Alison Clague, Curator of the Charnwood Museum.

Great care has been taken to confirm the copyright details of the old photographs used in this book. The author thanks all who have assisted in this task.

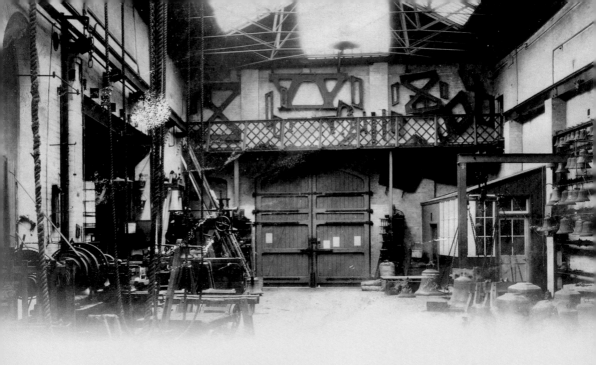

CHAPTER 1

Still Summoned by Bells

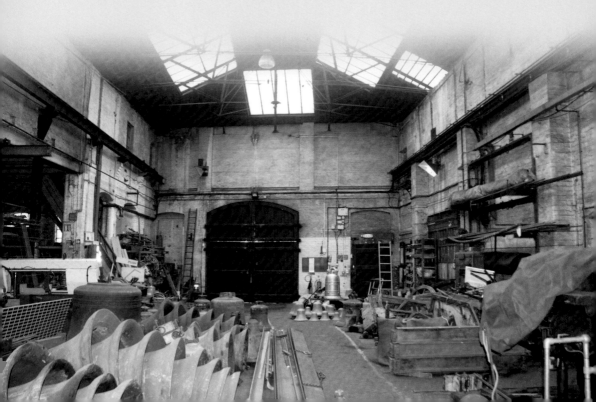

We have been making bells from metal for over 3,000 years. In Britain, bells were originally closely associated with religious buildings, and the traditional bell-making skills followed the spread of Christianity across the country, carried out predominantly by monks. The Venerable Bede refers to large bells as early as the seventh century and it is known that St Dunstan (909–988) was a practised maker of bells.

Many of the early bell founders would travel to where their skills were required. The bells would be cast near to the church that had commissioned them, and sometimes even inside the church. The materials required would have been sourced and purchased locally, and in some cases the documents recording the cost of each item have survived. Archaeological excavations have revealed the remains of furnaces in some churchyards. In practical terms, the largest bells were those most likely to have been cast near their church because of the difficulties of transporting objects of such weight.

However, gradually, the bell makers did set up permanent foundries in the larger towns, and many produced other metallic items, such as guns and kitchen utensils, in order to maintain a steady income.

John Taylor came to Loughborough in 1839 to recast the bells in the parish church of All Saints in the town. The base of the church tower is dedicated to the Taylor Company. Taylors recast the ring of ten bells again in 1897–99.

For two decades, the company operated from premises in Pack Horse Lane in the centre of the town and moved to their present site in Freehold Street in 1859. A fire badly damaged the Freehold Street buildings in 1892, but they remain the home of the company today and constitute a rare example of a Victorian building in which the same company and same industry has been operating since its construction.

Taylors introduced their five-tone principle of bell tuning in 1896. This produces the purity and sweetness of tone and allows the bell to sound with full and rich mellowness. This gives Taylor bells their special characteristic and sets them apart from all other cast bronze bells. The bell master and the bell tuner work on five principal harmonics – the hum, fundamental, tierce, quint and nominal – but these in turn influence and affect many others. When the correct frequency for each of these harmonics has been achieved, the bell is in tune with itself. In a set of bells, each bell is tuned using the same standards applied to its own frequencies and thus each bell in the set is not only in tune with itself, but also with each bell in the set.

There are now only two bell foundries in Britain. The foundry in Loughborough is the largest in the world. Despite struggling financially for survival in recent years, the company is now once again a busy place with a full order book, its workers continuing a direct tradition and profession which has been unbroken since the middle of the fourteenth century when Johannes de Stafford, a Mayor of Leicester, was active only 10 miles away from the present foundry.

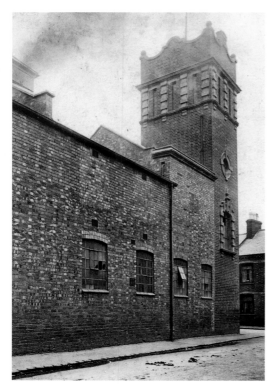

The Bell Foundry, Cobden Street
The familiar tower of the Bell Foundry standing at the junction of Freehold Street and Cobden Street. Taylors moved here in 1859 from nearby Pack Horse Lane. In 1892 a fire seriously damaged many of the buildings.

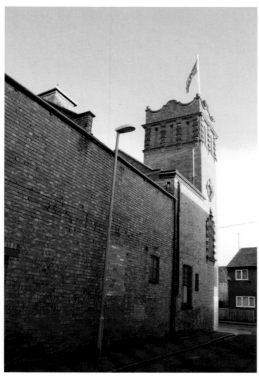

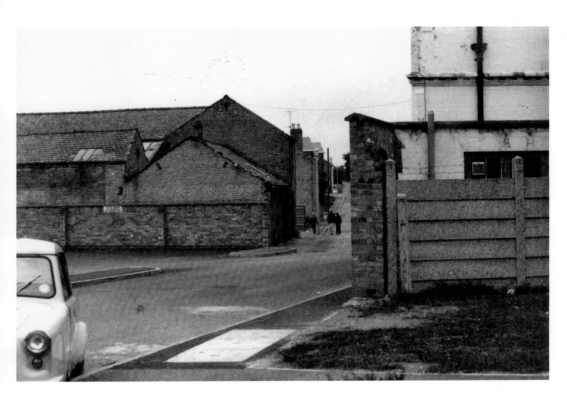

The Bell Foundry, Freehold Street

Looking along Freehold Street towards Queens Road with the frontage of the foundry on the right. The older photograph was taken soon after the garage – formerly the stables associated with the foundry, and which stood opposite the factory – had been demolished.

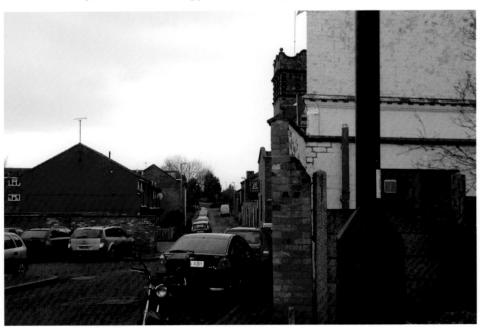

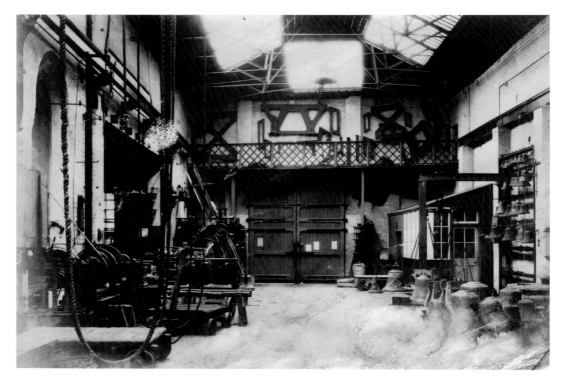

The Bell Foundry, Interior

A view of the main erecting hall of the foundry, which has seen the casting and tuning of many bells of all shapes and weights. The overhead gallery has been removed, but little else has changed over the past 150 years.

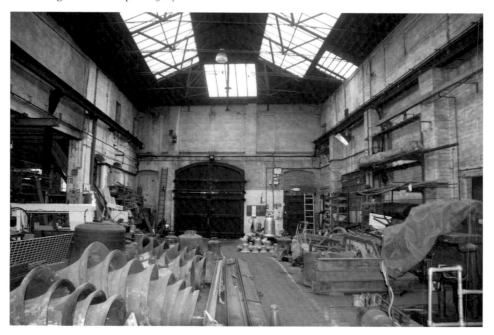

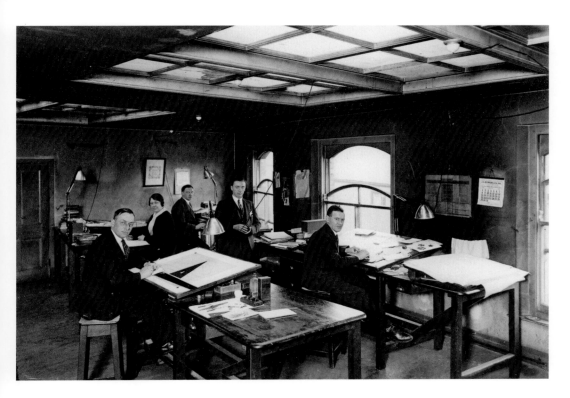

The Drawing Office

The Drawing Office, photographed in the 1930s. The windows in the ceiling provided natural light in which the draughtsmen could work and see more clearly the details of their designs. In 2013 this area was being renovated before being converted into a meeting room.

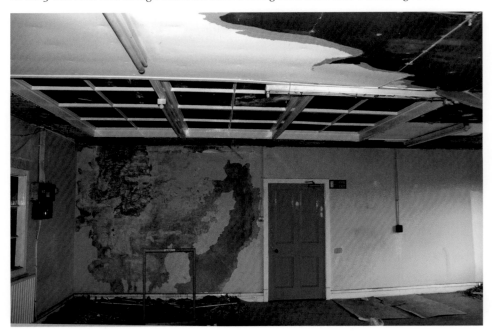

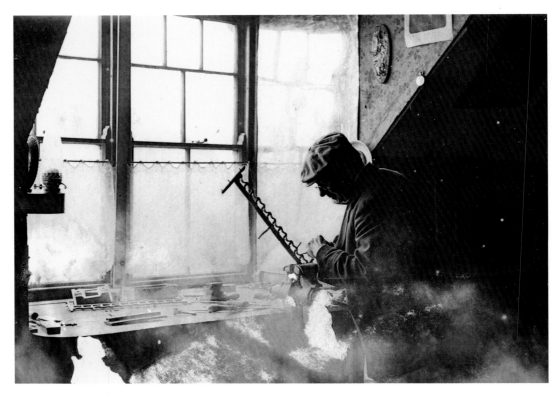

Foundry Workers

Evocative images of different processes in casting bells, spanning many decades. The man in the older photograph is probably using a scaling measure for drawing out 'stickles', the patterns from which the moulds are made. The colour image is of a bell being cast in 2011.

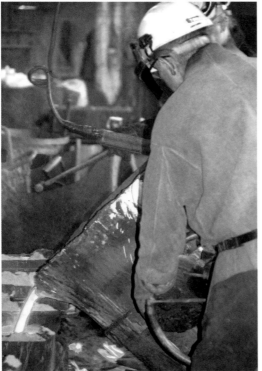

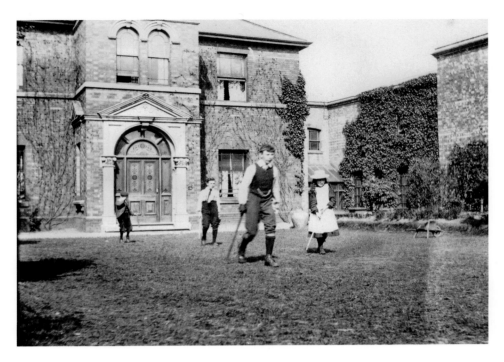

The Foundry House

At one time, members of the Taylor family lived next door to the foundry. This public open space is where the Foundry House once stood. The present foundry buildings are on the right. The view is of the rear of the house and its garden looking from the present Peel Street towards the end of Freehold Street.

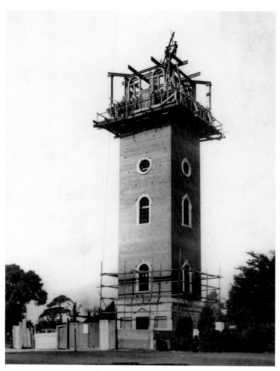

The Loughborough Carillon, Construction

A very significant monument and a much-respected and admired building, the Carillon Tower was built as a war memorial by public subscription in memory of the 480 local men who fell in the First World War. Bronze tablets on the exterior of the tower commemorate the fallen of both World Wars and subsequent conflicts.

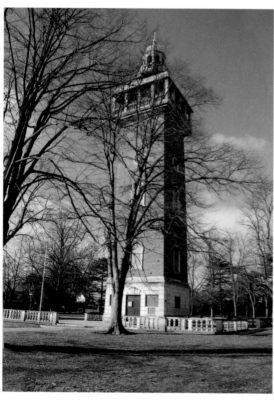

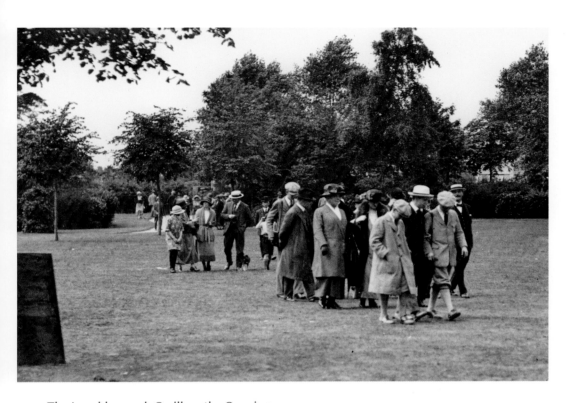

The Loughborough Carillon, the Opening

The bells were all cast at Taylor's Bell Foundry. The opening recital was given on 22 July 1923 by Chavalier Jef Denyn of Malines in Belgium. The original music for the Loughborough Carillon, *Memorial Chimes*, was composed by Sir Edward Elgar. Carilloneurs still give regular recitals.

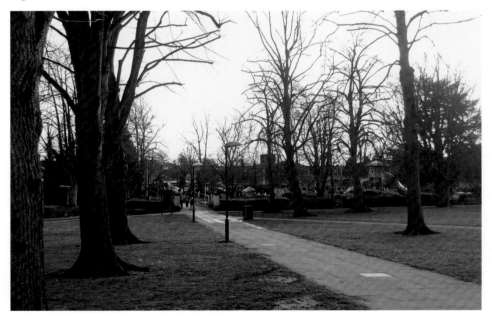

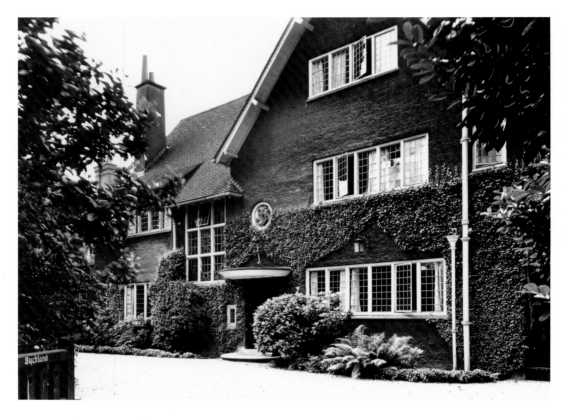

No. 6 Burton Walks
This delightful house, built around 1910 in the Arts and Crafts manner of Charles Voysey, was the residence of Edmund Denison Taylor of the Bell Foundry company. It was given Grade II listed status in 1984 and now serves as offices for Loughborough Grammar School.

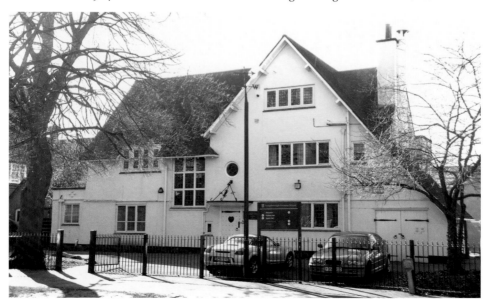

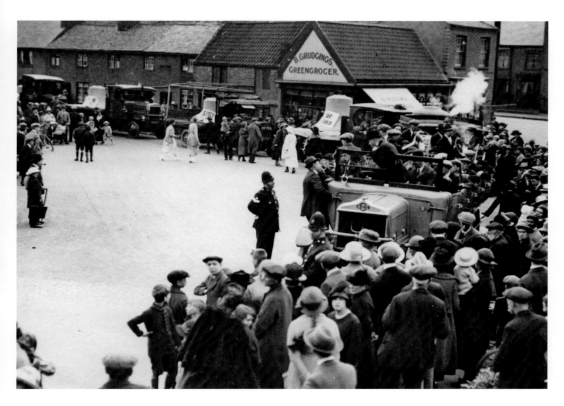

Taylor Bells in Transit

Bells leave Loughborough and sometimes return. The colour image is of the bells of Christchurch Cathedral in New Zealand, damaged in the earthquake of 2011 and returned to the town for repair.

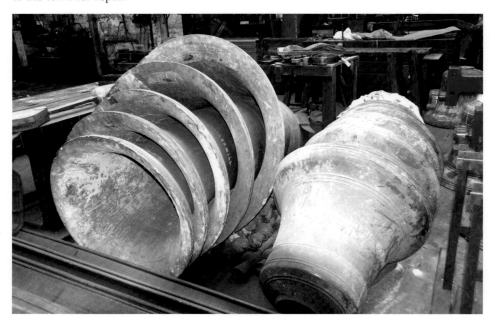

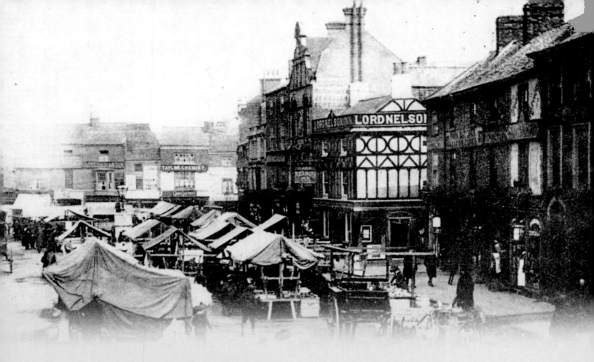

CHAPTER 2

The Town

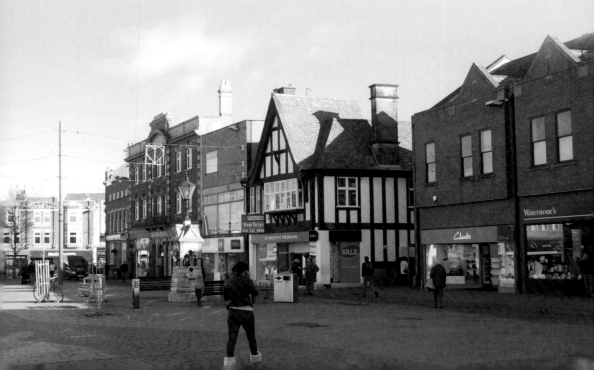

The distinguished architectural historian Nikolaus Pevsner had little to say about Loughborough. In his typically terse style he reported (in 1960) that the town 'in spite of its 35,000 inhabitants, has hardly a house, let alone a street, in its centre, which would require mention'. He did, however, mention the churches, the town hall, and the Carillon, which he described as 'brick with a big fanciful top'.

It is true to say that Loughborough does not have the quaint character of the other market towns of Leicestershire, such as Melton Mowbray and Market Harborough, but it is a town that has been influenced more by the industries of the eighteenth and nineteenth centuries, and the need in the immediate post-war years to build a considerable number of new homes for those who worked in the local factories. Compared with Market Harborough's population of about 20,000 inhabitants, and Melton Mowbray's population of about 25,000, Loughborough was home to nearly 60,000 people in 2012.

Loughborough can make a unique claim in the context of travel and tourism. Today, the town is close to the country's motorway network, and only 9 miles from the East Midlands Airport. Back in 1841, it was the destination for the first ever package tour, when a group of factory workers travelled to the town from Leicester on an excursion organised by Thomas Cook. Loughborough has had a long-standing and important association with the railways as the home of Brush Engineering. The Great Central Heritage Railway is a nationally recognised tourist attraction, and the Midland Main Line that connects Loughborough with London and the north is to be electrified and upgraded within the next decade.

On market days, despite the dominance of supermarkets and high street chains, the Market Place in Loughborough is still the busiest trading area of the town; an urban space that for centuries has been alive with the sound and the colour of street traders selling not only local produce but also the exotic, and catering now for the tastes of the many different cultures that have made Loughborough their home. The market in Loughborough has been attracting traders to the town since the thirteenth century, and no doubt in even earlier times travelling merchants would have stopped here, between the Black Brook and the River Soar, roughly halfway between Leicester and Nottingham.

In the twenty-first century, Loughborough's market is held (and celebrated) on Thursdays and Saturdays, when over 125 traders set up their stalls. In the past, the space has witnessed many civic and corporate events, celebrating the coronation of a king or mourning the death of a queen, or providing a dignified arena for parades and processions.

There is a marked change in character and atmosphere between the Market Place and the area in which the parish church stands. Although only a short walk away, connected by the still-charming Churchgate, it is a different world. Far away from the bustle and bartering, it is a place with an air of dignified peace in which birdsong can still be heard in the middle of the day. It seems that the spiritual still stands above the noise of mammon.

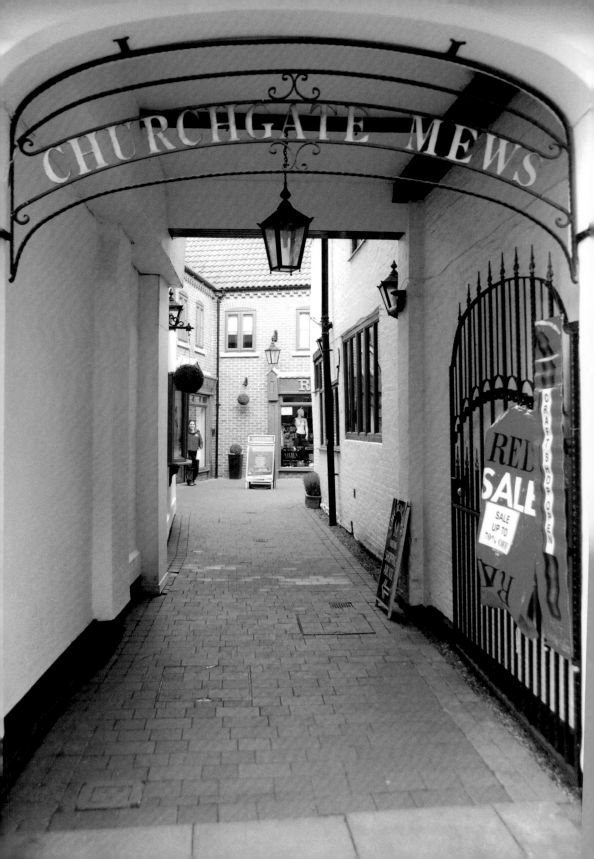

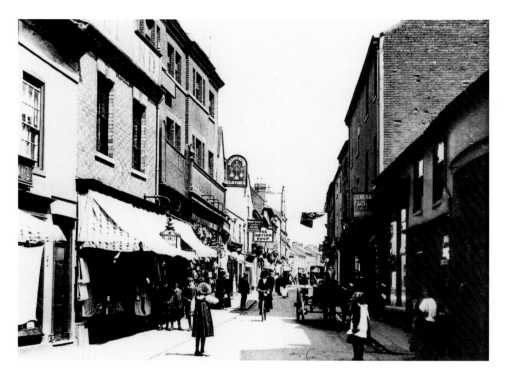

Churchgate

The view along Churchgate from Biggin Street in around 1900. Ten years earlier, this had been the first street in Loughborough to be surfaced with tarmac, an improvement that was no doubt appreciated by the lady riding her bicycle towards the photographer. This is the one surviving street in the town that retains its original medieval width of 18 feet.

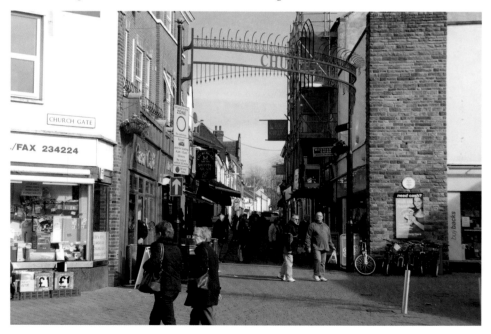

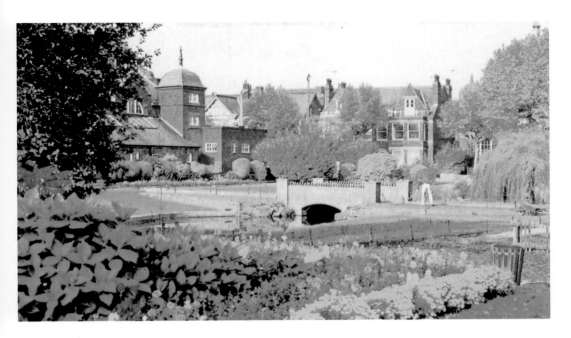

Queen's Park

The Granby Street swimming baths in Queen's Park were built to celebrate the Diamond Jubilee of Queen Victoria in 1897. They cost £3,000 and were paid for by Joseph Briggs, a wealthy timber merchant and later Mayor of Loughborough. They were opened by the Marquis of Granby on 10 August 1898. When the nearby leisure centre was opened in 1975, the old baths became redundant. The building reopened in 1999 as the Charnwood Museum.

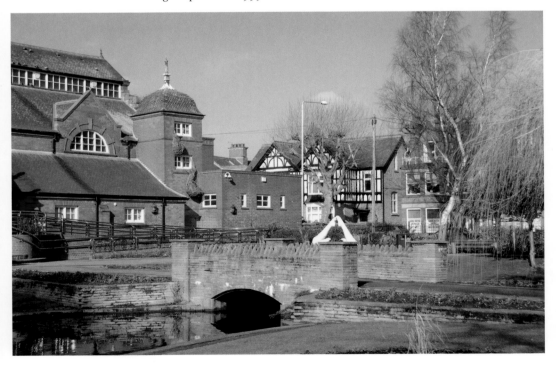

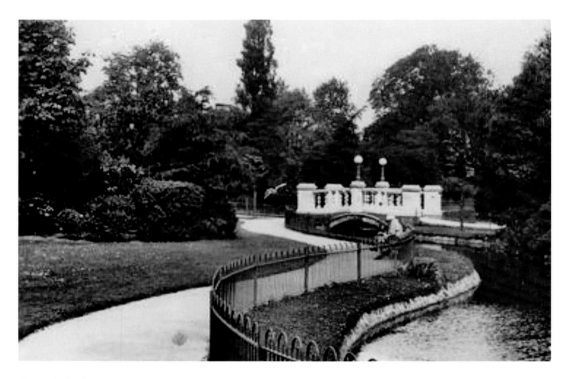

Queen's Park

The park was opened in June 1899 to celebrate Queen Victoria's Diamond Jubilee and to promote a healthy town. Initially, 4 acres of land were laid out as the park. A further 6 acres were added in 1905–07 and a final area in 1916 to create the park as it appears today.

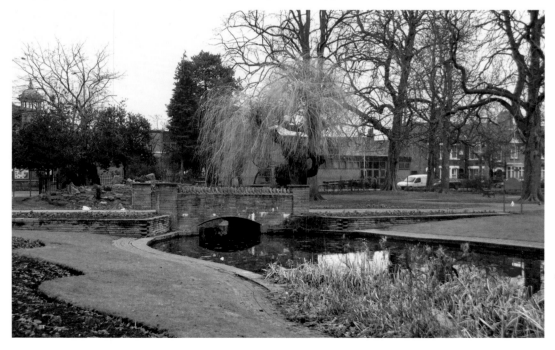

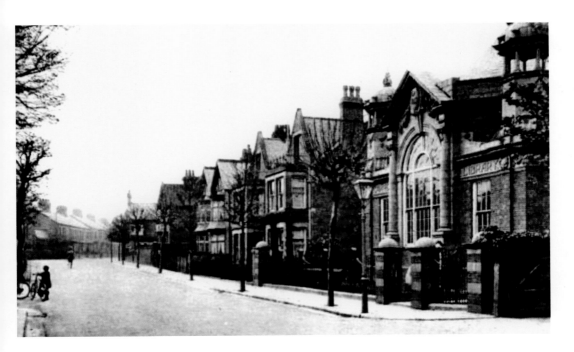

Carnegie Library, Granby Street
A remarkable building, imaginatively designed in an exuberant Baroque style by local architects Barrowcliff & Allcock, and opened in 1905. A librarian's house was included in the design. The building includes a wealth of fine detail such as terracotta decoration by the well-known and local firm of Hathernware. It has been sensitively enlarged and refurbished.

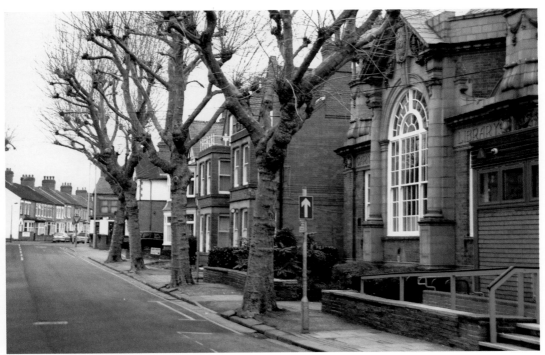

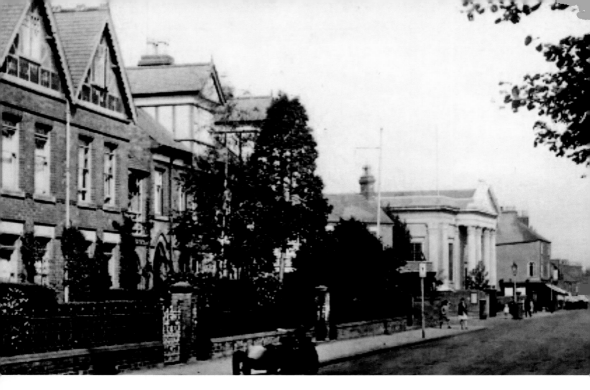

Ashby Road
Looking along the Ashby Road towards the town centre, the splendid Catholic church of St Mary's stands out within this otherwise red-brick suburban landscape.

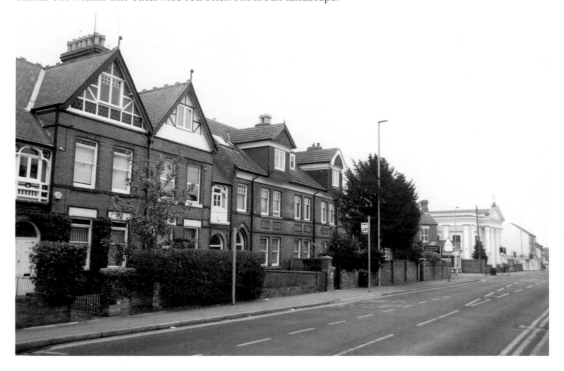

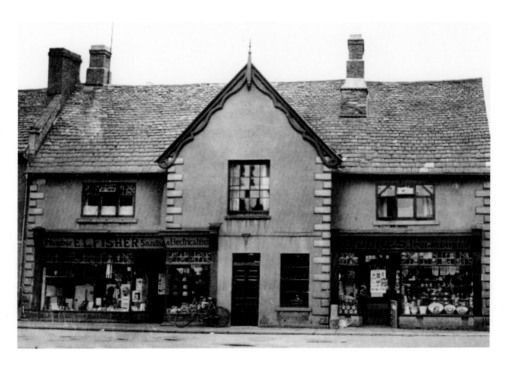

The Manor House

Standing in the shadow of the parish church, the Manor House was built in 1477. It has a roof of local Swithland slate and a central gable facing the road where the original front entrance would have stood. At the rear were grounds which included a rabbit warren that gave its name to the nearby street, The Coneries. The ground floor has been divided into two shops, but much of the earlier timbering on the first floor has survived as well as two medieval fireplaces, one carved from a large solid block of stone from the Charnwood Forest.

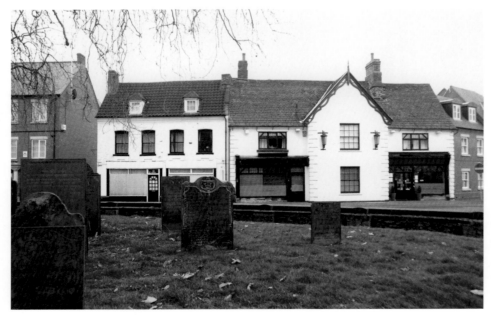

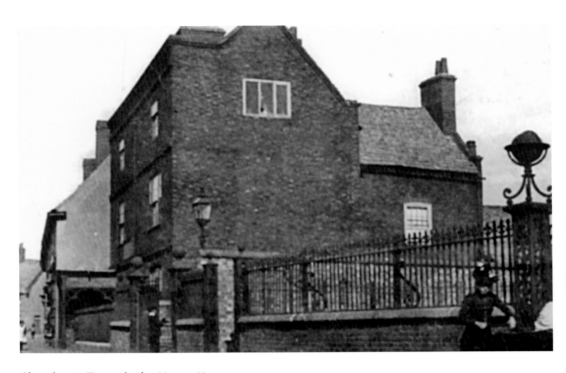

Churchgate Towards the Manor House

A view that has changed much over the years, looking along Churchgate by the side of the parish church. The white facing wall of the Taste of India restaurant is the only clue to the location.

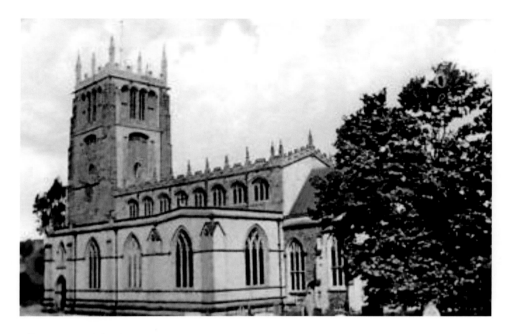

All Saints Parish Church

Despite heavy restoration in 1862, this is an impressive building of sedate dignity. Its scale and size match perfectly the surroundings, which include some of the oldest buildings in the town. The body of the church dates to the early thirteenth century, and its elevation suggests that the small hill on which it stands has been a place with spiritual meaning for much longer.

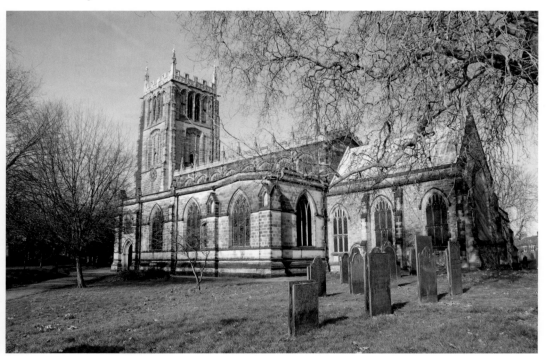

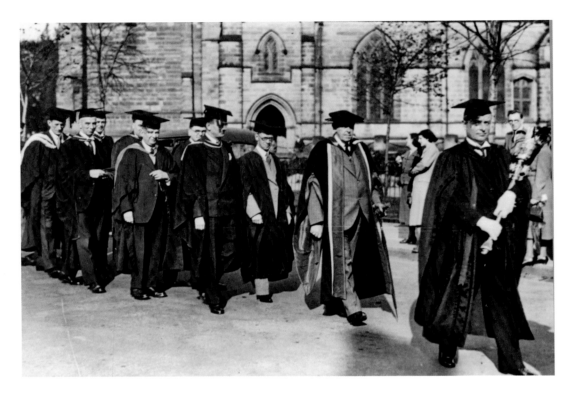

Loughborough College Procession

The parish church is also Loughborough's civic church and has witnessed many events, commemorations and celebrations. In previous years, this is where 'town' and 'gown' came together. The earlier photograph of a procession of academic staff from the college dates to the 1930s.

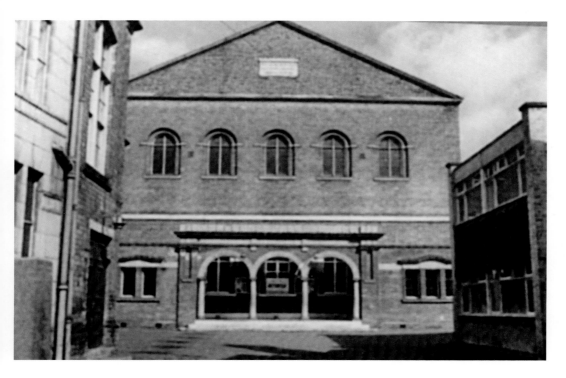

Baxtergate Baptist Church

Set apart from the former hustle and bustle of the street, this modernised frontage speaks of a lively church community. Here, the minister is opening the church early on a Sunday morning, as his antecedents have done since 1828 when this General Baptist Meeting House opened.

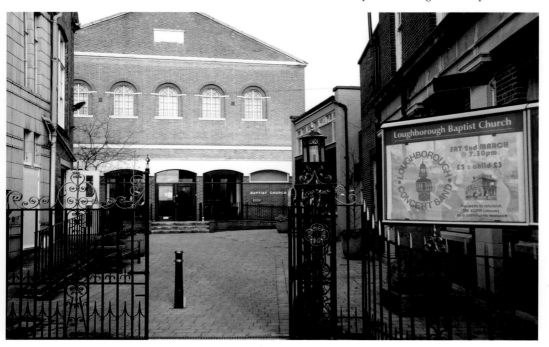

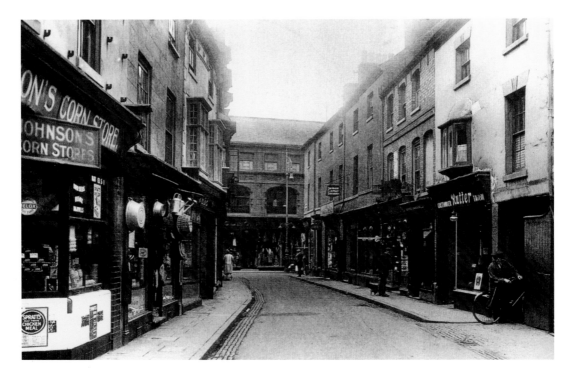

Baxtergate

One of three parallel streets in the town that echo the Danish word *gade* or *gata* for street, and which all lead towards the hill on which the parish church stands. Baxtergate was the home of the bakers. Tailor Archibald Rutter at No. 53a was a familiar figure in pre-war years.

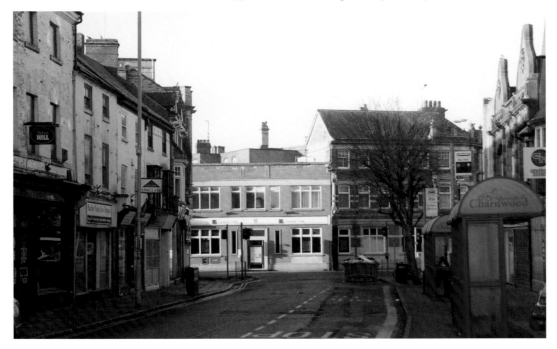

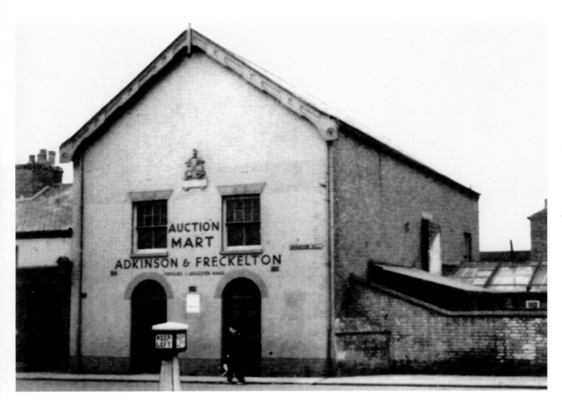

Sparrow Hill Theatre

The Sparrow Hill Theatre was built in 1822 at a cost of £700 and opened on Monday 2 June 1823. *Speed the Plough* and *Warlock on the Glen* were on the first night's bill. It was described as having an interior of 'extreme elegance' but was put up for sale in 1848 and reopened as a free church before becoming a lecture hall and music salon in the following year. In 1856 it was bought by the Manchester Unity of Oddfellows. From the 1950s, auctioneers Adkinson & Freckelton owned the building, and it is now a retail store.

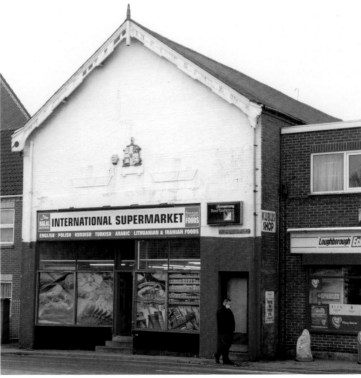

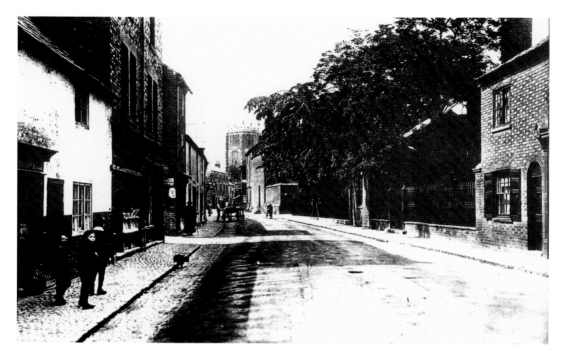

Sparrow Hill

A view along Sparrow Hill towards the parish church from the junction of Pinfold Gate and Hume Street. Traffic now dominates this road and disguises its original context, but towards the church, several of the surviving buildings have listed status and some date in part to the fifteenth century.

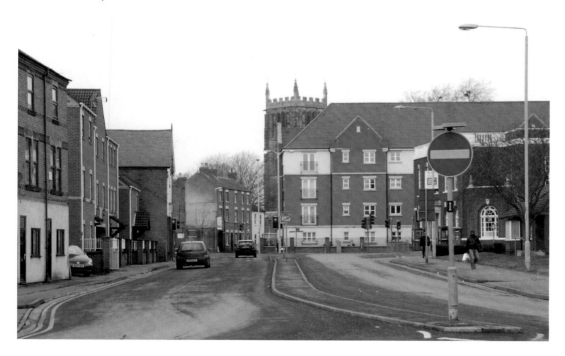

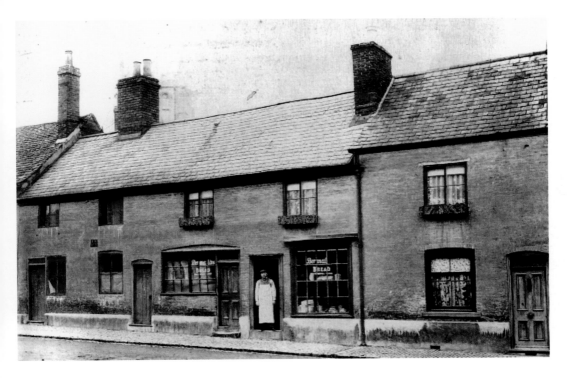

Sparrow Hill Shop

The community of Sparrow Hill now has to contend with constant traffic, as the street is part of the system that diverts vehicles from the pedestrianised central area of the town. Very little remains of the older buildings in the part of the street between Baxtergate and Churchgate.

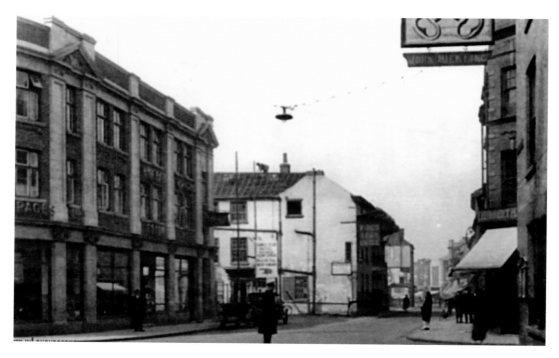

High Street

For most of the day, traffic dominates the High Street, and Loughborough's shopping centre is now focused on the streets and precincts which connect to it. The former Cross Keys can be seen in the older photograph, which is now the Phantom & Firkin.

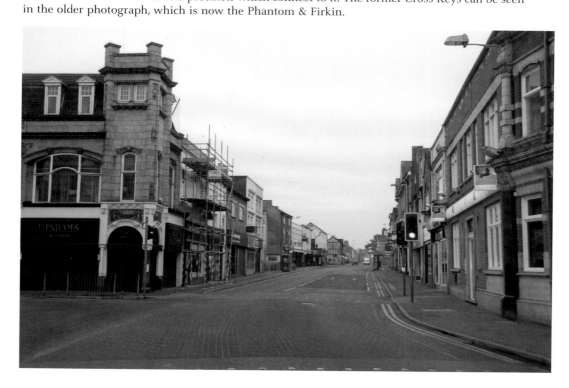

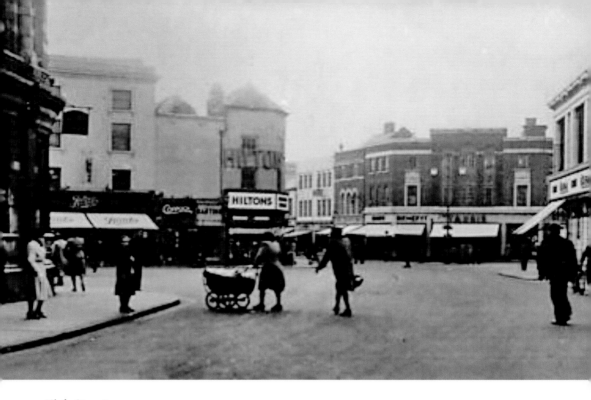

High Street

This view along High Street is towards Swan Street, with the Market Place on the left and Baxtergate on the right.

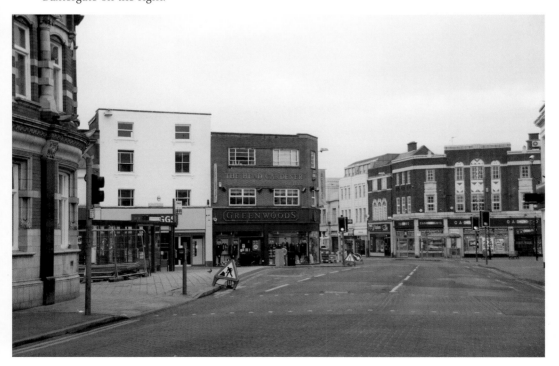

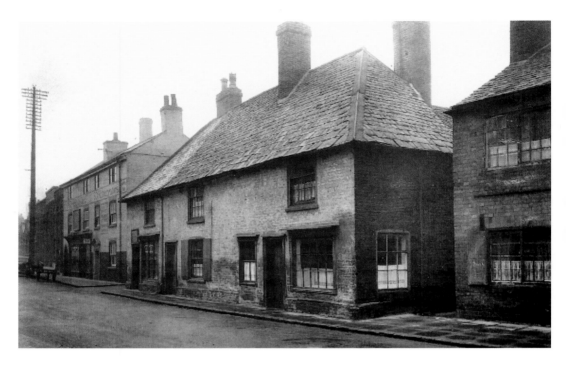

Woodgate

Originally the route by which timber from the Charnwood Forest was brought into the town, in recent years this street has changed beyond recognition, with few buildings from the nineteenth century or earlier having survived.

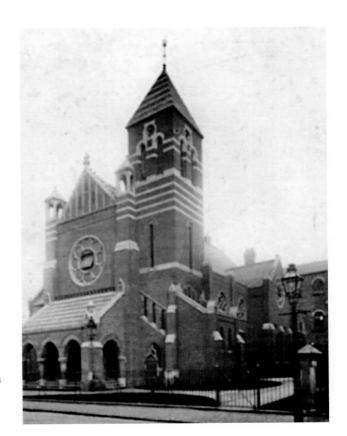

Woodgate Baptist Church
The Baptists first worshipped in Woodgate in 1792, and this imposing building was erected in 1878, with a later Sunday school extension over the site of the earlier building.

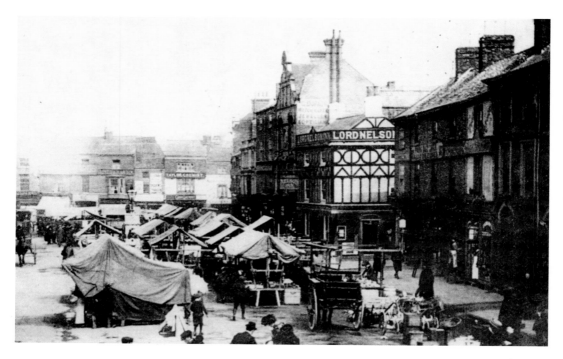

The Market Place, the Thursday Market, 1905
The economic and social heart of the town for many centuries and thus a location that is forever changing as retail establishments and hostelries come and go, and old buildings are replaced. However, the Lord Nelson public house provides a sense of continuity. Today, the building is a retail store for women's fashions.

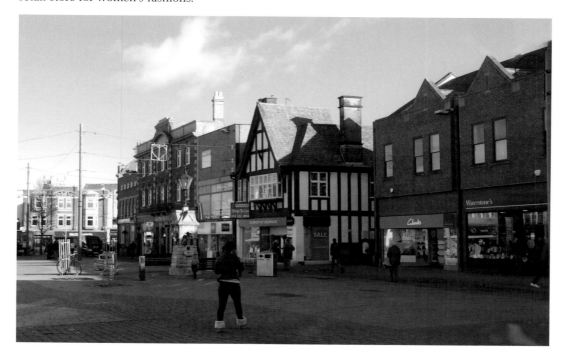

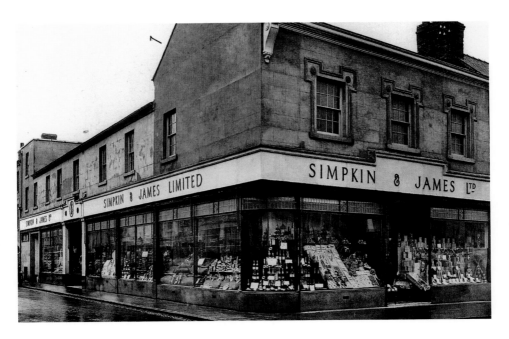

Simpkin & James

A familiar Leicestershire business that traded for over two hundred years. In Loughborough, their store was on the corner of Market Street and the Market Place. It was renowned for the remarkable variety of food and wines on sale. In recent years, the family relaunched the business as a wine shop. The grandson of a former managing director now runs a general store in a nearby village.

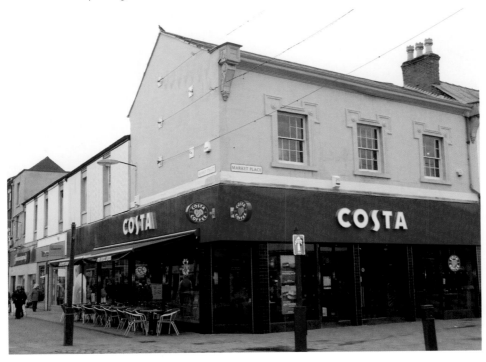

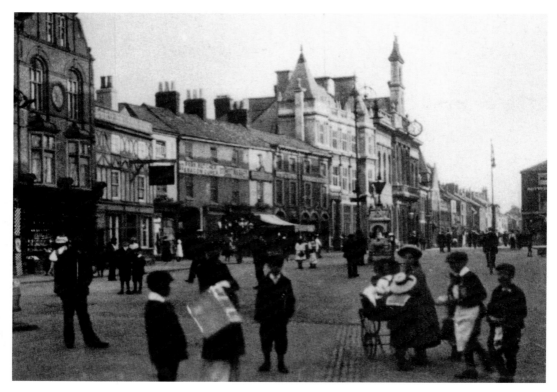

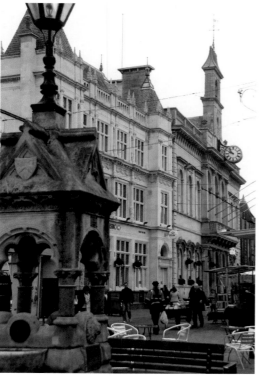

The Market Place and the Town Hall
Children gather in the Market Place in 1912.
The town hall was built in 1855 as the Corn
Exchange at a cost of £8,812.

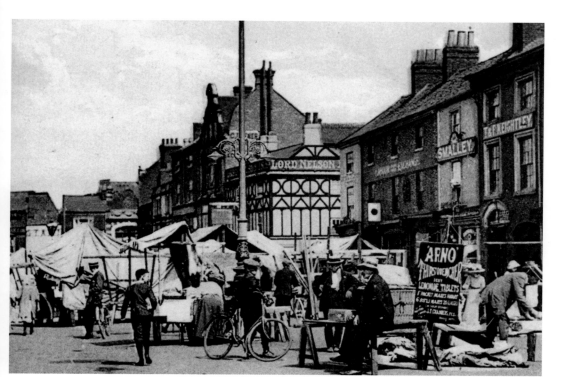

The Thursday Market

The nature of a market is a happy confusion of stalls and traders, and the basic elements of Loughborough's Thursday Market have changed little in the 200 years between these two photographs.

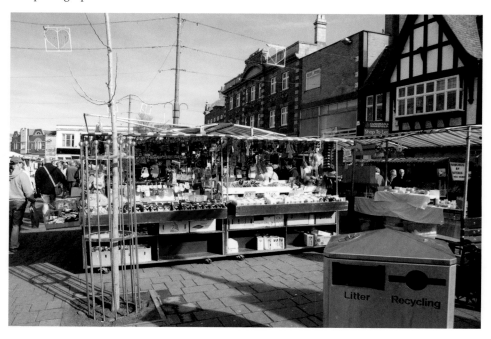

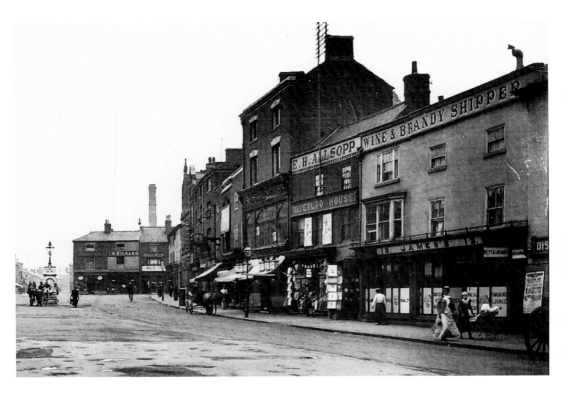

The Market Place

The older photograph, looking towards Devonshire Square, was taken in 1900. Hardly any of the buildings or the shops along the northern side of the Market Place have survived intact in the twenty-first century.

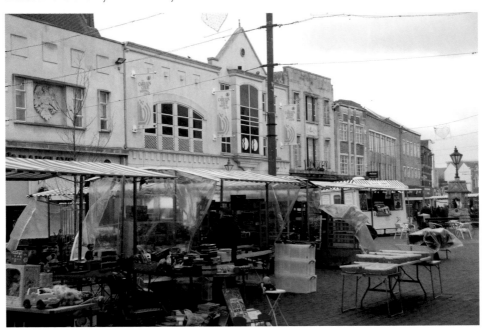

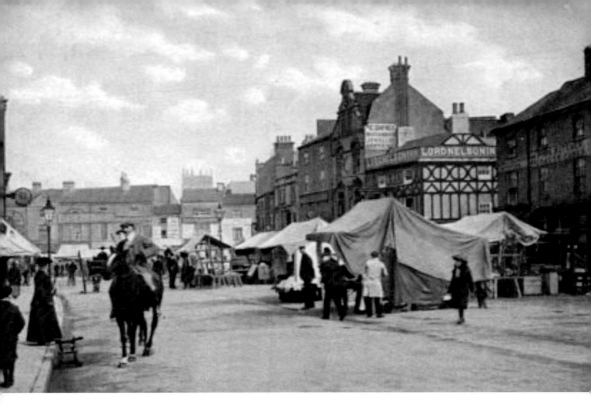

The Market Place
This view of the Market Place dates to around 1907. The tower of the parish church can be glimpsed behind the buildings in High Street.

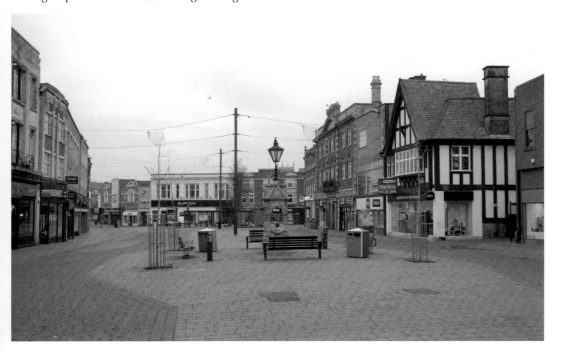

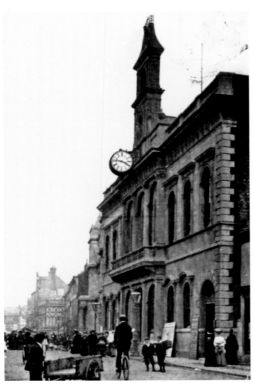

The Town Hall
A building of dignified proportions that stands overlooking the Market Place. It serves its purpose well as a venue for local music, theatre and the arts, as well as civic receptions.

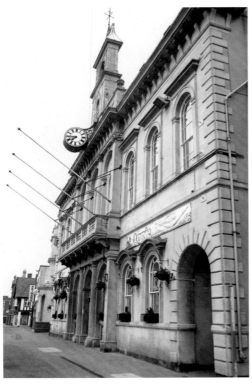

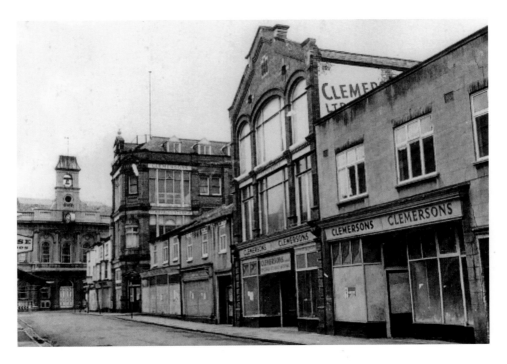

Market Street

Looking along Market Street towards the town hall. The former Clemersons, 'the complete home furnishers' and at one time, the town's only department store, can be seen on the right in the earlier photograph. Henry Clemerson was a native of Loughborough, born in the town in 1807.

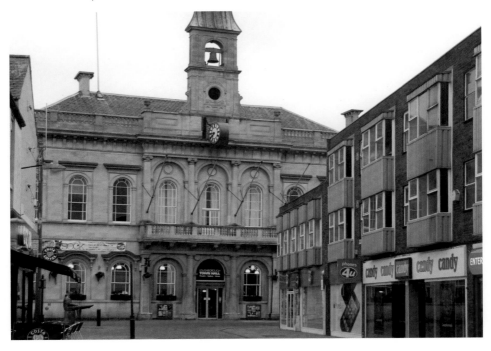

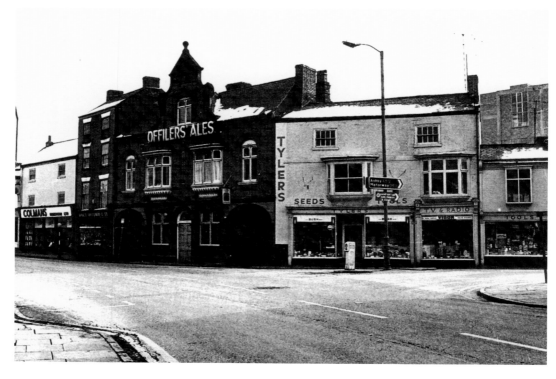

Tylers, Swan Street

This old and well-established local department store has remained in almost the exact location, despite being incorporated into the Carillon Shopping Centre. The former Coleman's shop is now Hartley's. The entrance to the shopping centre is where the Green Man pub once stood.

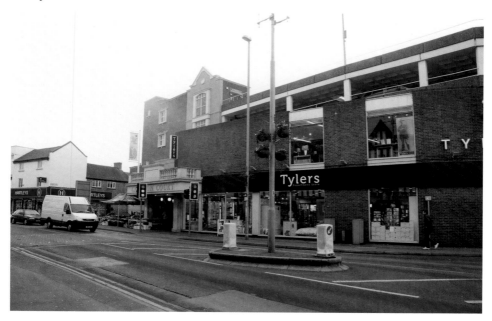

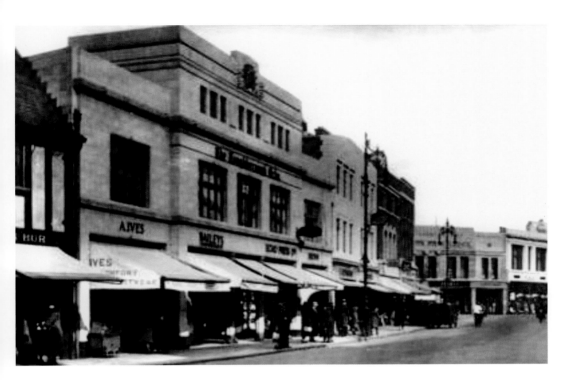

Swan Street

The *Loughborough Echo* building in Swan Street. The view is towards High Street. Founded by Joseph Deakin in 1891, the *Loughborough Echo* started life as a free sheet with just four pages. Eighteen years later, readers were charged a halfpenny per issue. The paper has had just four editors in its entire history.

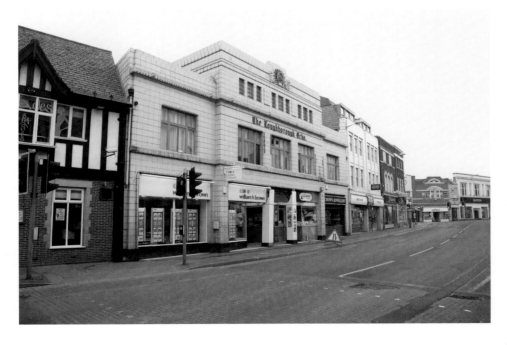

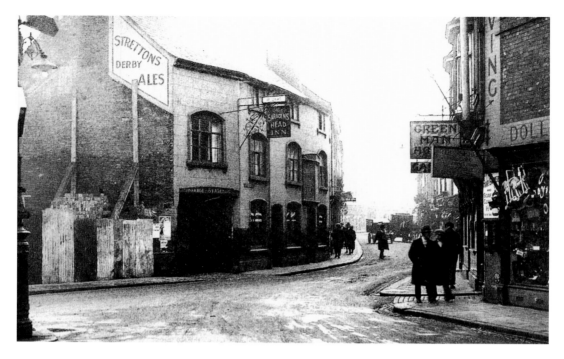

Swan Street from Derby Square

This earlier photograph is a reminder of the atmosphere of the streets in the centre of the town before the widening that took place in the late nineteenth century and early twentieth centuries. The Green Man pub was subsumed within the Carillon Shopping Centre, and the bar still exists beneath several shop units. Drinks were last served in the 1990s.

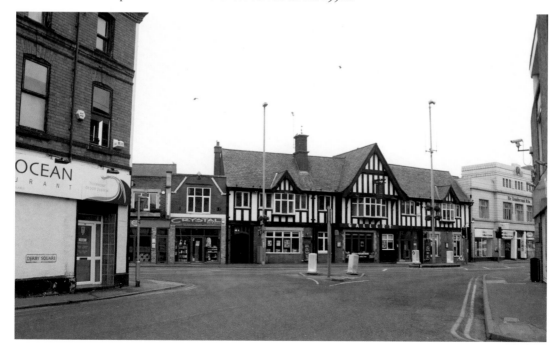

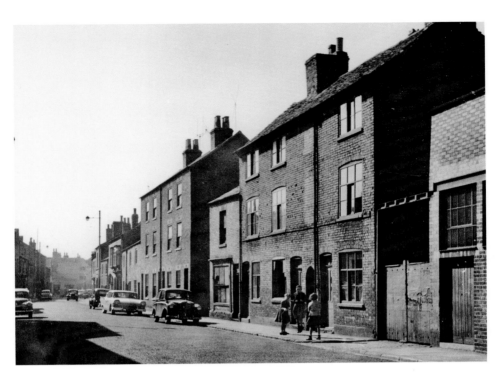

Pinfold Gate

The Pinfold or pound existed in many villages and was where stray livestock would be kept until claimed by their owner, usually on payment of a fine. Unclaimed animals were sometimes sold at the local market. No doubt in centuries past this was the case in Loughborough.

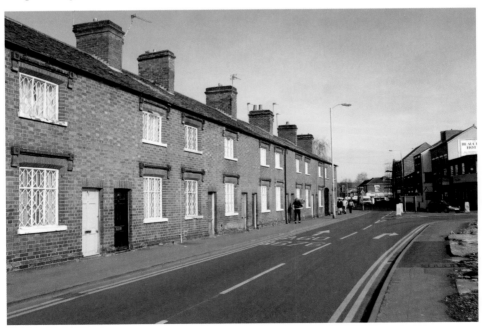

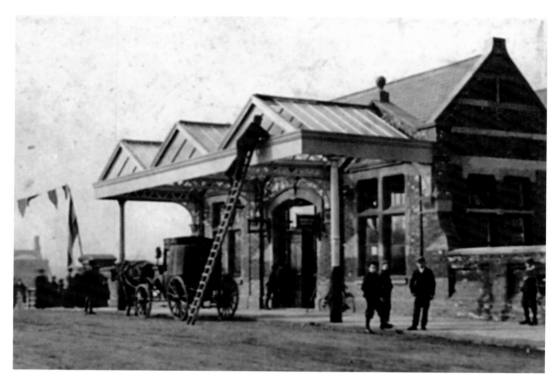

Great Central Railway Station Entrance

Compared with the grand exterior of Leicester Central, the scale of the Great Central Railway's station in Loughborough seems rather quaint. Now a world-acclaimed heritage railway, this is the gateway to the only double-track steam railway in Great Britain.

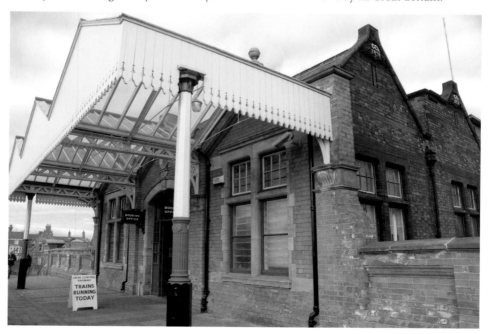

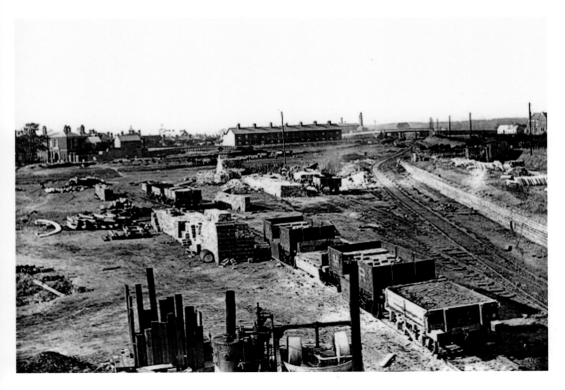

Great Central Railway Station

The GCR station in Loughborough was opened on 15 March 1899, and this earlier photograph shows the platforms and trackbeds being laid. It reopened in 1974. Some of the former railway land has been sold for residential development, but the remaining tracks are alive with vintage steam and diesel trains.

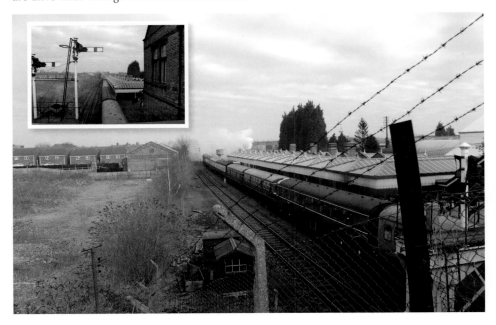

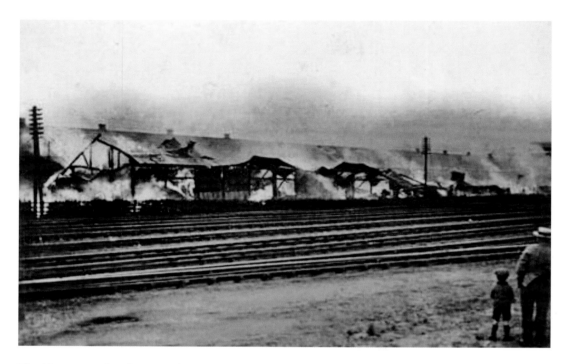

The Fire at Brush Falcon Works

A long-standing major employer in Loughborough, Brush came to the town in 1889 when the Falcon Works were purchased. A devastating fire broke out on 30 July 1921 when the local workforce numbered almost 2,500 men.

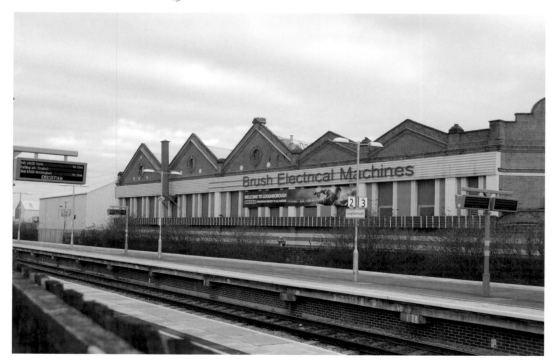

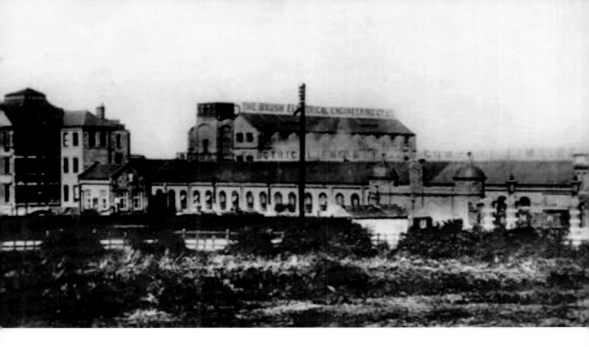

Brush Turbogenerators

Over more than a century, Brush has been producing many different types of engines at its factory in Loughborough, including steam locomotives, power units for Channel Tunnel trains, and now the most advanced turbogenerators.

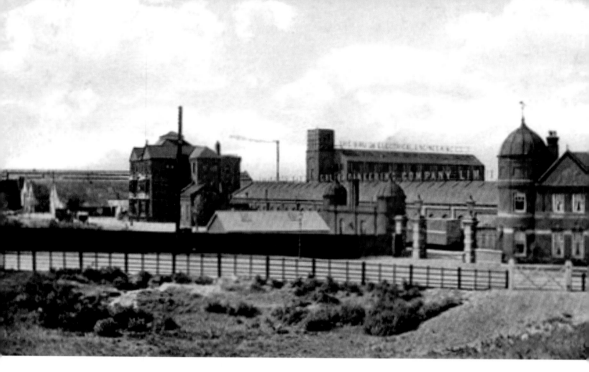

Brush Turbogenerators

Brush is still a major employer in the town, and a significant name in advanced engineering concepts. Its founder was an American, Charles Francis Brush, who was born in Cleveland, Ohio, and who developed his first dynamo in 1876.

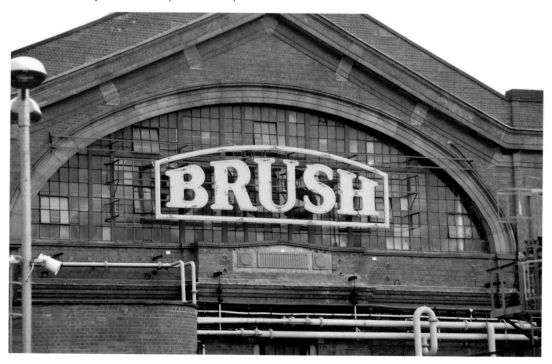

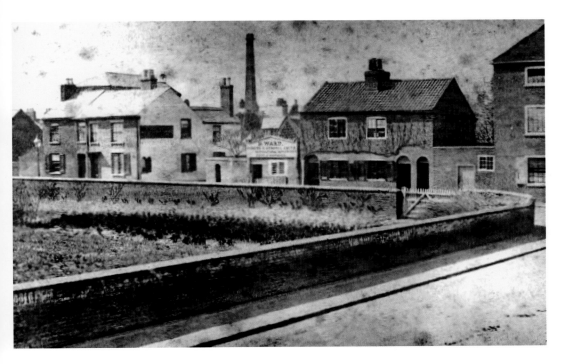

Leicester Road, Southfields Road Junction

Until the modern route of the A6 road from Leicester was extended to meet with Loughborough's Epinal Way ring road, this was the gateway to the town from the south. The land next to Southfields Park is now dominated by the modern offices of Charnwood Borough Council.

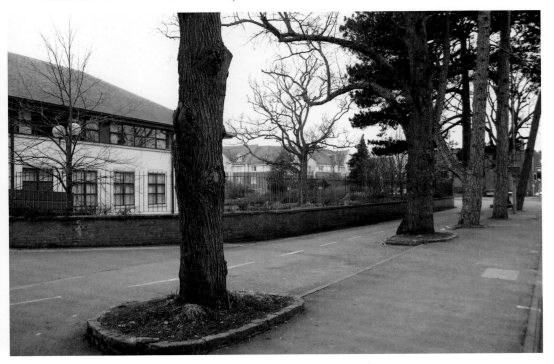

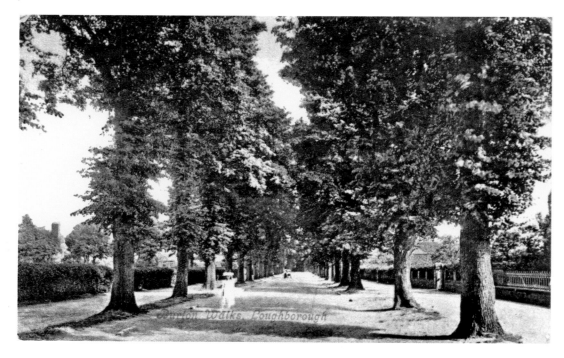

Burton Walks

The avenue of Burton Walks was laid out in 1850–52. Its name commemorates Thomas Burton, the local merchant and benefactor who established the predecessor to Loughborough Grammar School. Originally the avenue was planted with elm trees, but these were replaced with lime trees following Dutch elm disease.

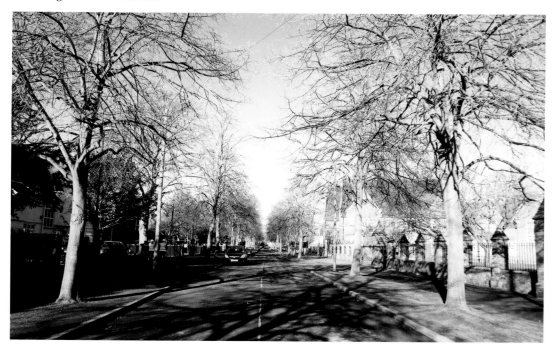

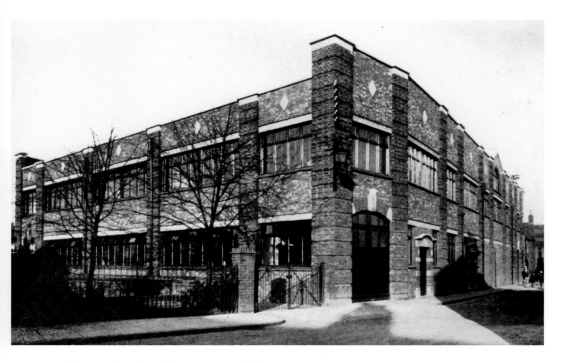

Loughborough University Sports Facilities

Loughborough University, the leading British university for sport and sports science, grew from the Technical Institute, which was founded in 1909 in the heart of the town. This archive image is of the college gym in William Street and dates to around 1933. The modern campus, not far from the western end of William Street, provides the latest facilities for around 18,500 students.

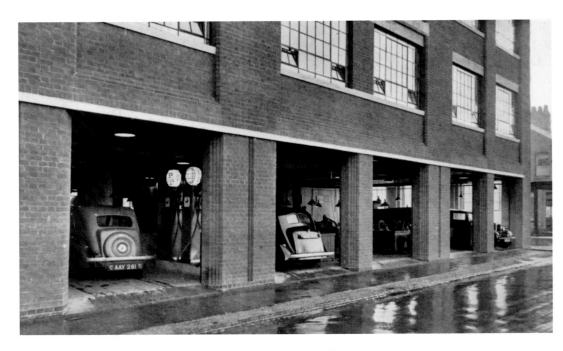

Frederick Street, College Garage

A modern structure in its time, this was the garage and service station for the early Loughborough College. The motor vehicles date the older photograph to the late 1930s. Adjacent, on Packe Street, was the college's own generating station, now a gallery.

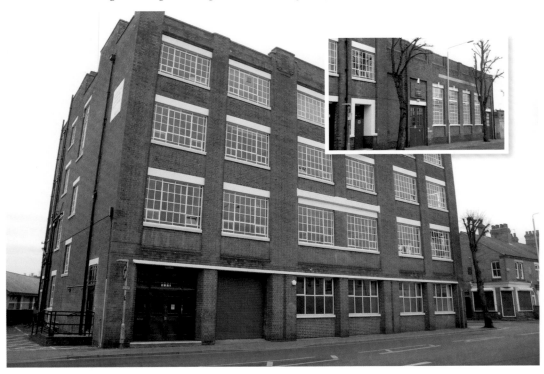

CHAPTER 3

Thorpe Acre

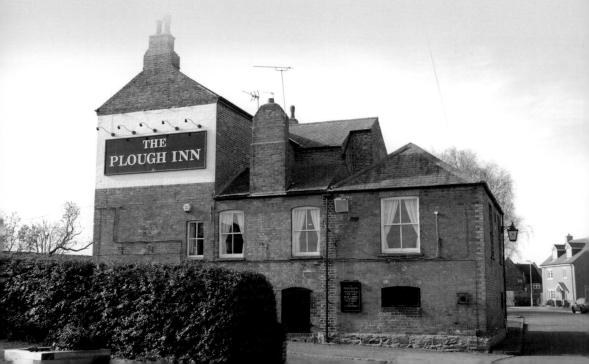

The landscape often defines the location of a settlement. The topography of an area can provide a place that can be defended easily, or a point at which several important routes converge, or where fresh water is available either by means of springs or watercourses.

In the case of Loughborough, the earliest settlement was certainly on the top of rising land, and was situated relatively close to the River Soar, as well near to where routes to all four points of the compass crossed; and on to the west, the Black Brook provided a suitable boundary.

Travellers on the roads that connected Loughborough to the old Charnwood Forest followed the then meandering course of the brook. They would have passed through a number of tiny hamlets, such as Thorpe Acre and Knightthorpe, before crossing the Garendon estate, with which these villages were closely associated, and finally reaching the larger settlement of Shepshed.

The word 'thorpe' usually means a settlement that has grown out of an earlier nearby village, prompted possibly by economic necessities such as the need to use more land for agriculture. In the context of Thorpe Acre, 'acre' does not relate to the familiar measure of land but to the practice of hawking, as in the bird of prey. The name of the village could therefore be interpreted as the 'settlement of the Hawker'. The ancient sport lives on in the name of a modern road, Hawkers Close, on the Thorpe Acre housing estate.

The Domesday record indicates that at that time, Thorpe Acre was a thriving settlement with twenty-seven households, the majority being villagers, but the population also including eight smallholders and three freemen. The village mustered six men's plough teams and the land included a meadow that was thirty acres in size.

Thorpe Acre probably changed little over the centuries. Prior to the Second World War, there were no more than twenty houses together with a church built in the nineteenth century, a rectory, church school, pub, post office, and a farmhouse. However, the returning troops and the need for the engineering factories in Loughborough to return to a peace-time manufacturing structure heralded dramatic changes for this little community.

In the 1950s, Loughborough needed more housing, specifically to accommodate the growing work force at the Brush Engineering Works in the town. As a result, part of Thorpe Acre was developed for residential housing, but in the following decades the entire area surrounding the village, and occupying all the available land between the village and the town, was chosen for a large housing estate. The old village of Thorpe Acre was totally absorbed by the new development,

but, remarkably, has retained its individuality and a little of its ancient character.

Today, Thorpe Acre is reached from Loughborough's ring road along the Alan Moss Road, which is named after a local man who was Mayor of Loughborough in the 1920s. Within the estate, some of the ancient names have survived such as Knightthorpe Road, Thorpe Hill and Garendon Road. The old Black Brook is still present within this new urban landscape, culverted in places, but being used as part of the open spaces on the estate that encourage wildlife. Cycle paths and footpaths criss-cross this estate, some respecting earlier routes, with interpretative panels and signposts along the way that tell new residents of the underlying history of the place.

Today, the houses of the Thorpe Acre estate almost spill out onto the landscaped open spaces of Garendon. Although the roar of traffic on the nearby M1 is noticeable, for the most part the Garendon estate – now a private farm – is still quiet parkland with the characteristics of its deer park landscape still obvious.

To some extent, this landscape is no less 'man-made' than neighbouring Thorpe Acre. Over eight hundred years before Thorpe Acre and Knightthorpe were to disappear as unique settlements, the ancient village of Garendon was erased from the landscape to make way for a Cistercian abbey. From the eighteenth century, engineered terraces and follies, and its carefully-designed views created a different environment, and this changed again when the first major motorway project in England sliced through its western land.

Indeed, the comparison of the old and new is most pertinent here, as Loughborough in the twenty-first century is continuing to grow, and the M1 is perhaps the new Black Brook, a major feature of the landscape that may ultimately define the final limits to the town's growth.

Towards Barnett's Farm
Very few of the older buildings have survived. This is a view along Thorpe Acre Road towards Knightthorpe Road from the junction with the present Chatsworth Road in the centre of the village.

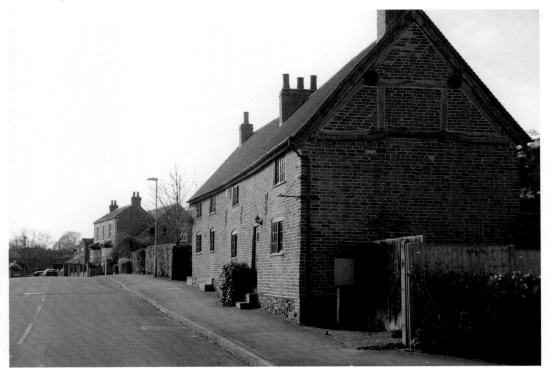

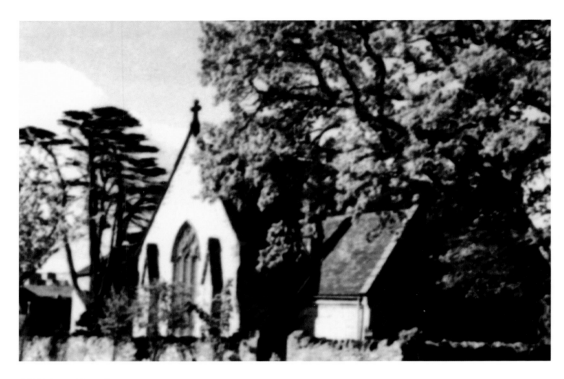

All Saints Church

In the 1960s, when this photograph was taken, the parish church of All Saints, Thorpe Acre with Dishley was still in a rural setting. The church was built in 1845 and extended in 1968.

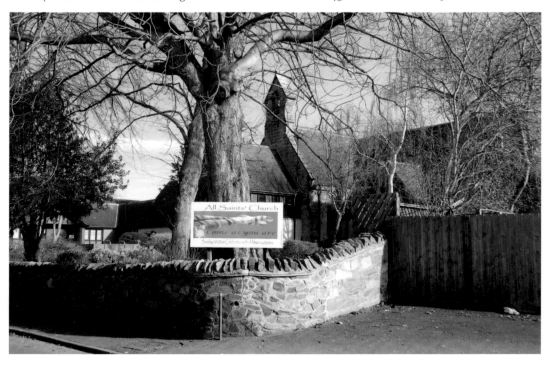

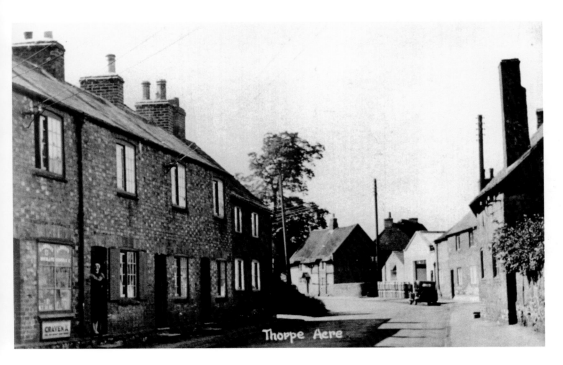

Thorpe Acre Village Centre

A view of the centre of the village in the 1930s. The house in the centre of the older photograph has survived, but all those around it are of modern construction.

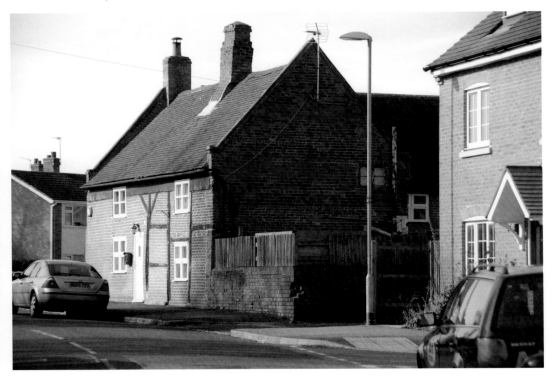

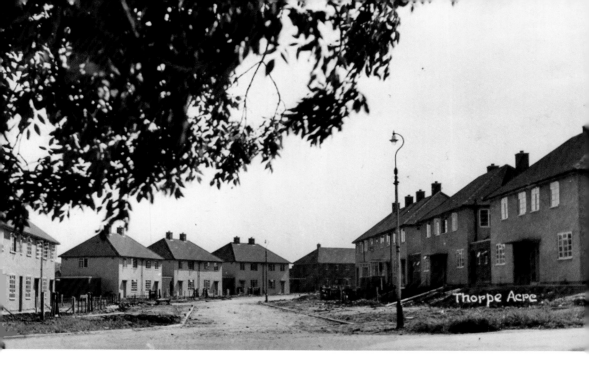

Rupert Brooke Road

The older photograph shows Rupert Brook Road nearing completion in 1950. Many of the first residents were employees of Brush Traction in the town, a company that was at the forefront of Loughborough's post-war regeneration.

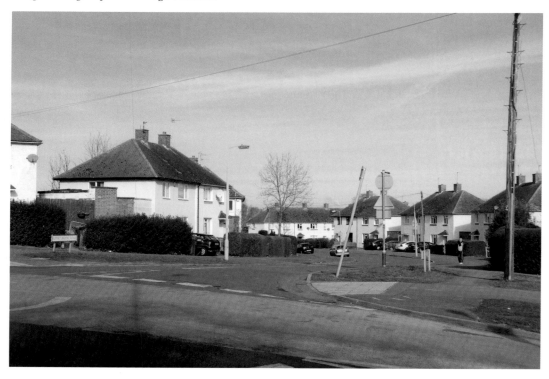

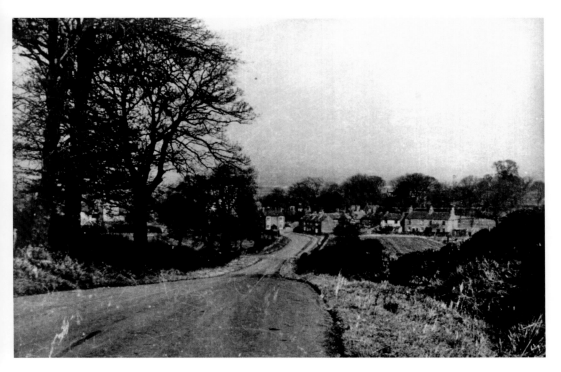

Thorpe Acre from Thorpe Hill

The date of the earlier photograph is 1948, when the old village was on the brink of a period of massive redevelopment. The present village green is in the middle of the newer photograph. The tower of the parish church is just visible behind the branches of the tree.

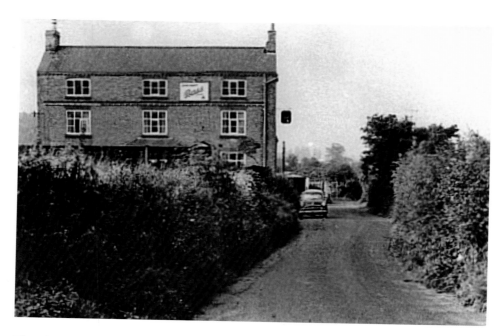

The Plough Inn

This old public house dates back to at least the middle of the nineteenth century and is probably older. It was at the very heart of the old village and, remarkably, has survived into the twentieth century. The view in the earlier photograph is towards Gorse Covert. The marshy area between is now a supermarket car park.

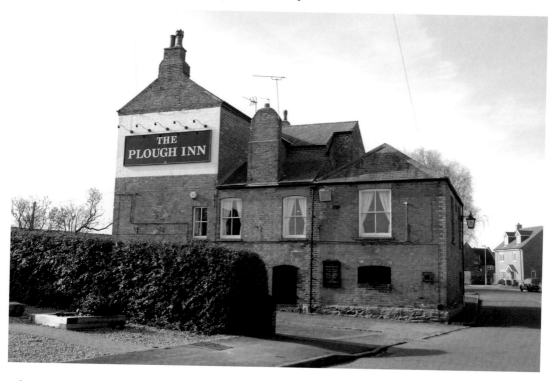

Thorpe Acre Church School
The village school stood next door to the church. The present junior school, which has more than 250 pupils, is nearby. The old school building has been converted into a modern church hall.

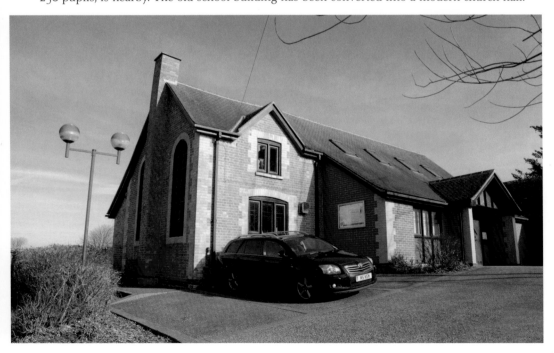

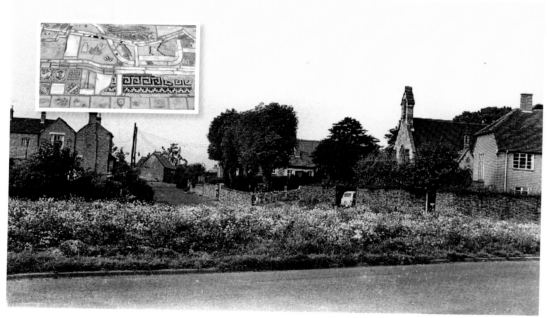

The Village Green

The present green was created after the Second World War. Previously, part of the land was used for allotments, and the main road to Shepshed crossed the land. Today it looks tidier and better maintained than in earlier times. A mosaic telling the history of the village was set up on the green to celebrate the millennium.

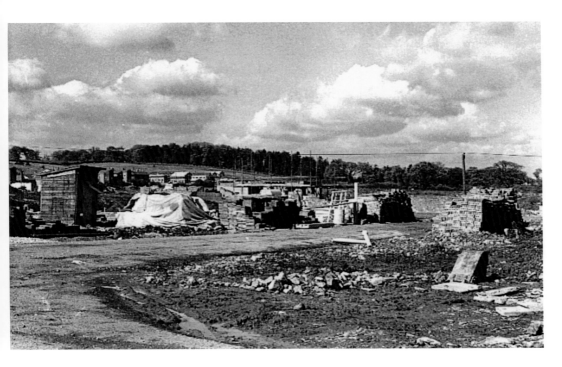

Buckingham Drive
It is difficult to confirm the precise location of the earlier photograph of houses being constructed on what would become Buckingham Drive. The trees on the horizon are obscured today. The Duke of Buckingham owned the Garendon estate in the seventeenth century.

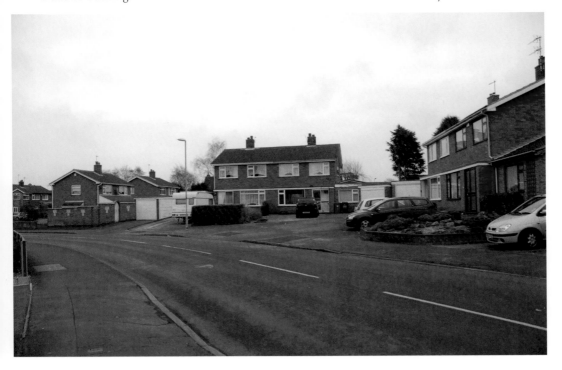

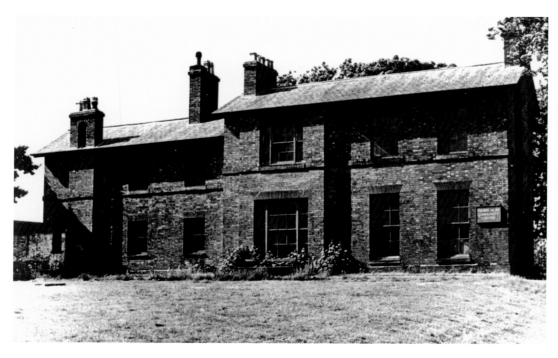

Thorpe Acre Rectory

The rectory, which stood immediately behind the church, was demolished in the 1950s. A small campus of bungalows was built on the site. The churchyard, which includes a number of Swithland slate headstones, remains.

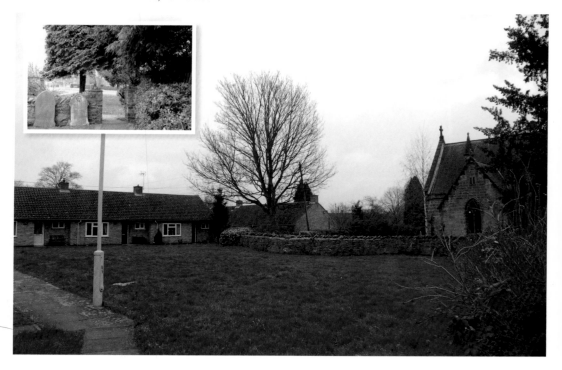

Knightthorpe Road

This road was originally a country lane that connected Thorpe Acre with the neighbouring hamlet of Knightthorpe. In the late nineteenth century, Knightthorpe consisted of twelve houses and fifty-eight inhabitants. Today the road is a part of the intricate network of the Thorpe Acre estate.

CHAPTER 4

Garendon

Loughborough does not stand aloof and disconnected from the surrounding countryside. Like many towns and villages, its origins lie in the early landscape, the hills and the valleys, which in turn defined the course of the streams and rivers, and the routes of communication.

Today, the town of Loughborough is connected physically with the ancient ecclesiastical estate of Garendon by the urban sprawl of Thorpe Acre. Bus services, conveying residents of the housing estates into the town, now follow closely the ancient routes towards Shepshed and onwards to Charnwood Forest, and commuters live within the shadow of Garendon's noble obelisk, which once stood alone upon a remote hillside.

Founded in the wild county of Charnwood Forest in 1133 by Robert, Earl of Leicester, Garendon was one of the earliest Cistercian abbeys in England. Its name derives from the Saxon 'Gaerwald's Dun', a settlement that survived for several centuries before being obliterated from the landscape and from history when the abbey was constructed and its lands were laid out. This small community is noted in the Leicestershire Survey – as 'Geroldon' – just eight years before the monks arrived, which suggest that the end of the settlement was short and therefore traumatic.

Over time the abbey grew steadily in wealth, its principal income being derived from agriculture and sheep farming. But its reputation, or at least the reputation of the monks, became tarnished over time, with a considerable number of reports of incidents of indiscipline and even violence between the lay brothers and the monks.

At the Dissolution of the Monasteries in 1536, the monastery was in a poor state and ruinous. Within a short time the abbey church was demolished. The remaining abbey buildings were left to decay into complete ruin. The estate and buildings were granted by Henry VIII to the Earl of Rutland for the sum of £2,356 5s 10d and it was he who built the first house at Garendon. The estate stayed with them until 1632 when, on the marriage of a daughter, it passed as a dowry to the Dukes of Buckingham.

The fortunes of Garendon changed direction again in 1684 when Sir Ambrose Phillipps, a successful London lawyer of the Middle Temple and King's Sergeant to James II, purchased the estate for £28,000, well over £4 million in today's currency.

Sir Ambrose died just seven years later. His son William inherited Garendon and extended it. Although he made very few changes, the estate grew and provided the family with enough wealth and status to enable Ambrose, his eldest son, to go on the Grand Tour of France and Italy after he had inherited Garendon in 1729.

The Grand Tour provided Ambrose with far-reaching ideas and ambitions for Garendon. Reflecting on what he had learned during his tour, particularly regarding the architecture of Rome, he set about creating a landscape which not only demonstrated his learning and culture but also provided a new vista from his house. He had canals cut and avenues of trees planted, and then turned his attention to the buildings.

The house was located on ground that was below the surrounding ridges on the southern and eastern boundaries of the estate. In his designs, Ambrose used this undulating landscape to great advantage, constructing a new classical landscape with several unique, classically inspired structures to draw the eye and catch the attention.

Garendon Hall was built on the site by a grandson of Sir Ambrose Phillipps from an Italian design in the early eighteenth century. The Phillipps family were still residents in 1926. Pevsner described the house as Palladian, as it had eleven bays and a large portico. Behind the house to the north was a range of seven bays, facing east, which he suggested might be of the late seventeenth century. The house was demolished in 1964. Excavations have located part of the abbey layout, including the chapter house, dorter undercroft and a drain.

As part of his master plan, Ambrose also designed the addition of the grand Palladian south front of Garendon Hall. However, it is thought that little of this building work had taken place when he died, aged just thirty, on 6 November 1737. The estate and house now passed to Ambrose's brother, Samuel, and it was he who took on the rebuilding of Garendon Hall to the existing Palladian designs.

This work created an elegant, though compact, eleven-bay by one-and-a-half-storey house, fronted by a full-height, tetra-style portico with Corinthian columns and an open, triangular pediment. Inside, the Great Hall was said to be particularly fine and not unlike the vestibule of the Doges Palace in Venice. On each side were built two gateways to designs by Inigo Jones, one of which still survives. The park is described in Benjamin Disraeli's political novel, *Coningsby*; he had visited Garendon in 1844, shortly before writing it.

As Samuel was the last of the male Phillipps line, on his death in 1796 the Garendon house and estates passed to his cousin, Thomas March, who also adopted the surname Phillipps. Thomas married Susan De Lisle, a member of an old family from the Isle of Wight. Their son, Charles March Phillipps (1779–1862) adopted the De Lisle crest and arms. It was his son (Ambrose Charles Lisle March Phillipps de Lisle, 1809–78) who had the commissioned Edward Welby Pugin, the son of the more famous Augustus Pugin, to alter and extend the

hall. Ambrose had also converted to Catholicism in 1825, at the age of sixteen years, and this was to influence his approach to the layout of the estate and the buildings within it. Clearly, Ambrose chose Pugin because of their shared Catholic faith, and he gave the architect very considerable funds to enable his designs to become reality; but the result was unsatisfactory in terms of scale and the unhappy merger of very different styles of architecture.

Financial stringencies following the deaths of Ambrose in 1878 and his son, also Ambrose, in 1883 prompted a necessary rationalisation of the estate. The heir, Everard March Phillipps de Lisle, and his young family moved away from Garendon into nearby Grace Dieu. This house had been built between 1833 and 1834 in their nearby estate close to the Grace Dieu Abbey ruins. The house had been constructed in a Tudor Gothic style by William Railton and enlarged with alterations by Augustus Pugin in 1847.

However, by 1907 the family's finances had improved and Edward, with his wife Mary and family, returned to Garendon. This action prompted, according to local newspaper reports, much popular support. The *Coalville Guardian* reported the speeches, music and celebrations that ensued and were enjoyed by crowds numbering around 6,000.

Sadly, the arrival of troops during the Second World War was to herald the end of the family's residence at Garendon. Part of the estate had been used prior to the First World War as a training camp involving the Leicestershire Yeomanry and the Territorial Army, with more than 17,000 troops passing through the estate's private railway station at Smell's Nook in 1911.

After the Second World War, the amount of damage and destruction that had taken place at the hall led ultimately to its final demolition. The heir to the estate, Ambrose (*b.* 1894) lived at Grace Dieu, but returned to his ancestral home in 1955. His death in September 1963 prompted high death duties, and all around, modern development, both industrial and residential, was encroaching. Eventually and inevitably, the hall was finally abandoned. In May 1964, it was demolished by the M1 motorway contractors McAlpine. The rubble was used as foundation for the road.

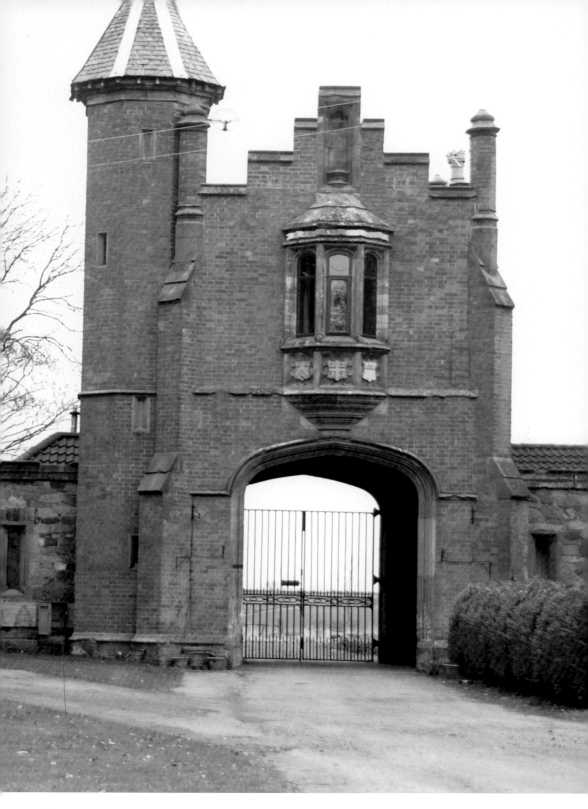

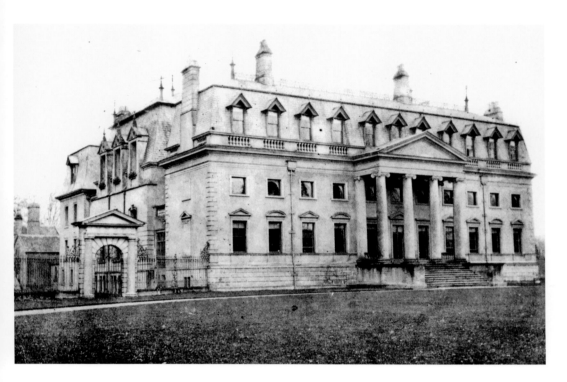

Garendon Hall
A dignified and stately building, even during its last years, with many broken windows to be seen. The hall was demolished in 1964. Only a few remnants of the outbuildings remain, but these are possibly medieval in origin.

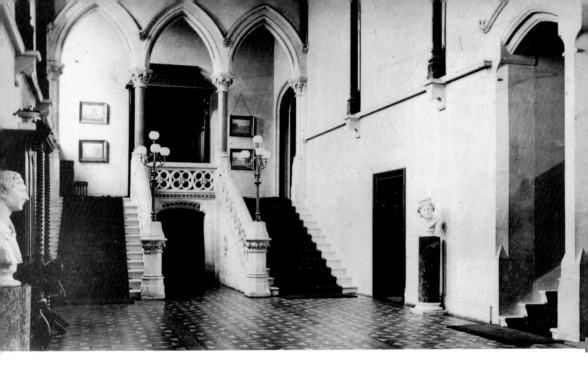

Garendon Hall Interior

The location for the hall was a precise aspect of a much wider plan by Ambrose Phillipps in the mid-eighteenth century, adding tree-lined terraces and water features to the natural landscape of the estate in order to create spectacular views from the rooms within the hall.

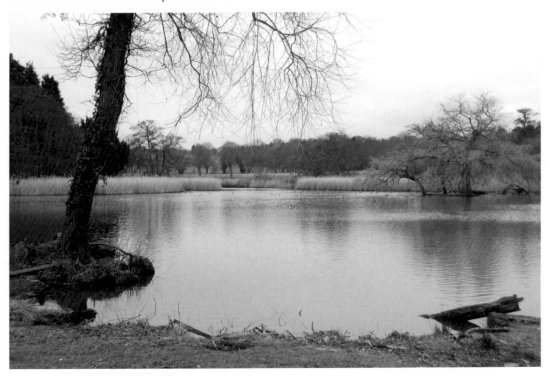

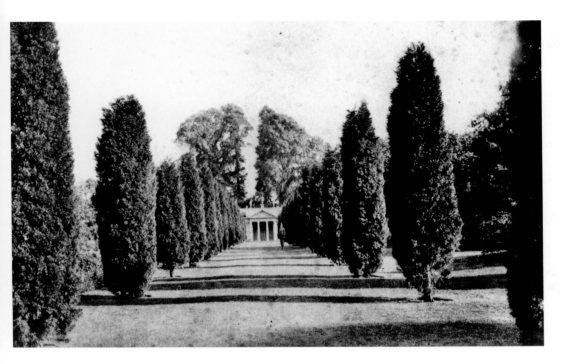

Garendon, the Temple

Visible from the M1 motorway, this circular building of ashlar Mansfield stone was based on the Temple of Vesta at Tivoli. It has no windows, but the interior includes some fine architectural features. The domed copper roof replaced the original one, constructed in lead and stolen in 1944. The temple also featured a statue of Venus, which was destroyed during local Luddite rebellions in 1811.

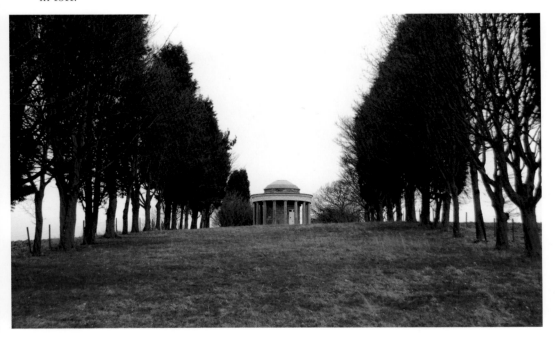

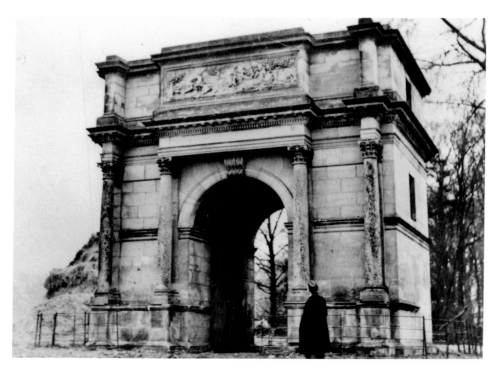

Garendon, the Triumphal Arch

Another element of the grand design of Ambrose Phillipps. The attic, crowned by a cornice, has a fine relief of the *Metamorphosis of Actalon*. Inside are some small rooms. Based on the *Arch of Titus* in Rome, this is possibly the earliest example of an English building inspired directly from an Ancient Roman source.

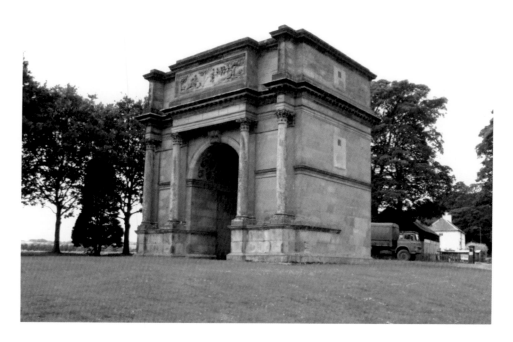

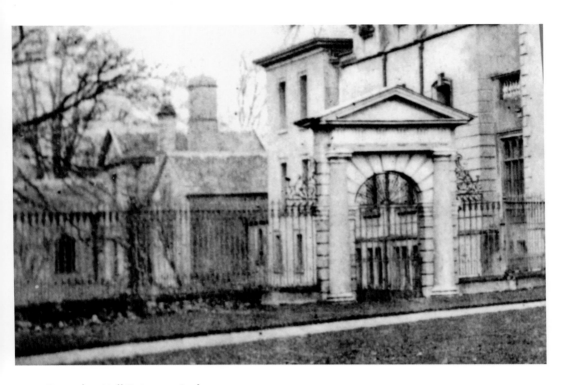

Garendon Hall Entrance Archway
Archways as gateways to new vistas was an important aspect of Phillipps' design. This entrance archway to Garendon Hall still stands, although now without its grand context.

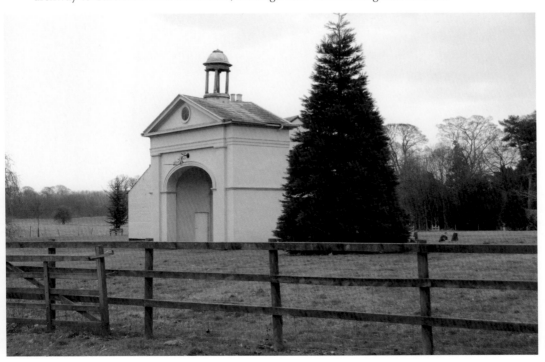

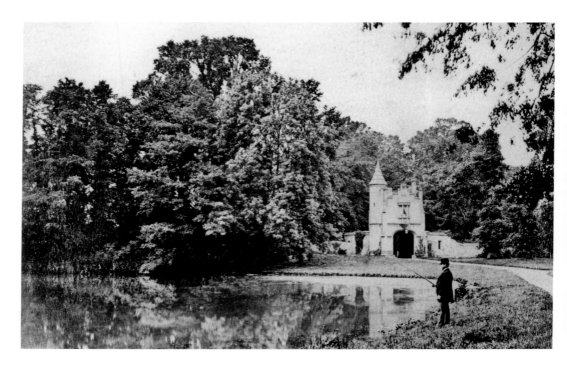

Garendon Lodge and Archway

Designed in the 1830s by William Railton, who exhibited the design at the Royal Academy, it was built in red brick with stone dressings and a pyramidal roof of local Swithland slate. This tranquil scene would have been the view from many of the hall's rooms. The small lake is today a rich habitat for wild fowl.

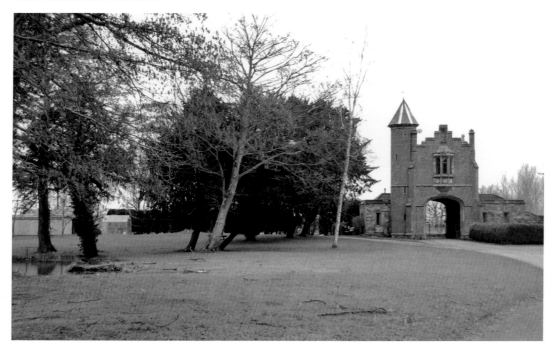

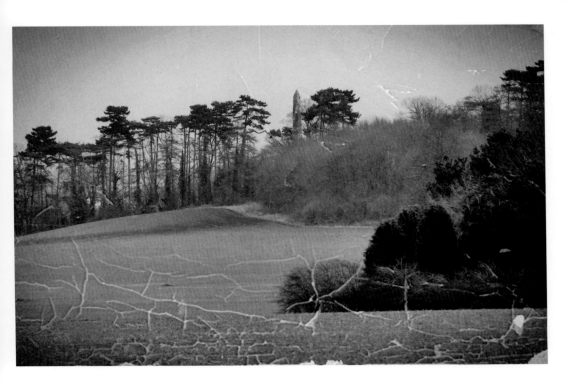

Garendon, the Obelisk
This distant view reveals the context of the obelisk, standing 675 yards east of the site of the hall. Built of slim, stuccoed red brick, the main spire rises to a height of nearly 80 feet. A double avenue of trees ran from the house towards it. Today, modern houses stand in the shadow of this splendid edifice.

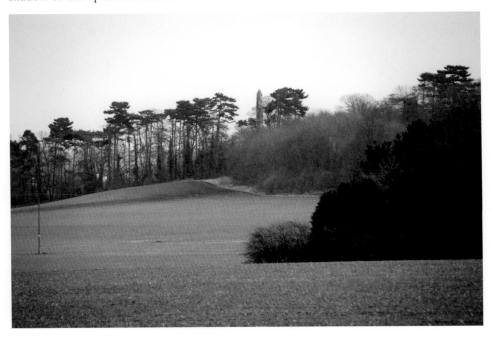

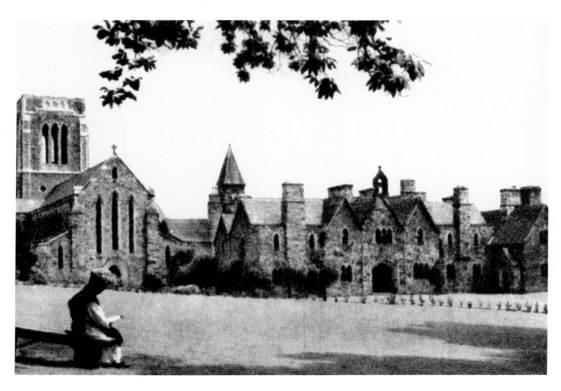

Mount St Bernard's Abbey

The Cistercians returned to the Garendon area in 1835, when Ambrose Lisle March Phillipps de Lisle founded Mount St Bernard's Abbey on 222 acres of his land. Augustus Pugin offered to design the abbey church and buildings for free.

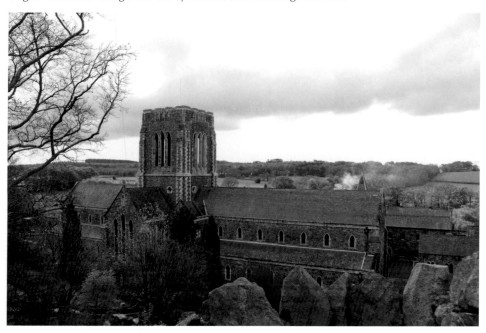

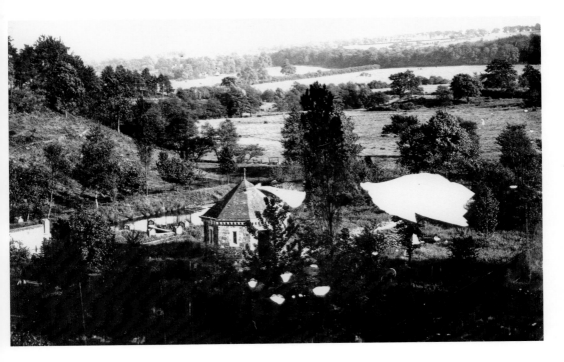

Blackbrook Reservoir

The reservoir was constructed in 1796 to supply water to the ill-fated Charnwood Forest Canal. The first dam was made of earth and collapsed on 20 February 1799, flooding local farmland and drowning livestock. The waters reached Loughborough. The present dam was constructed in 1906. In 1957 the dam felt the effects of a magnitude 5.3 earthquake. The vibrations caused heavy stones in the dam to move and cracks appeared.

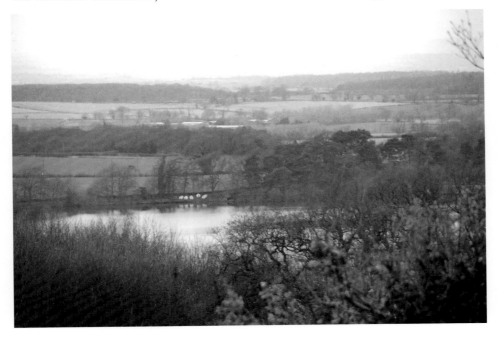